FRODSHAM & HELSBY

THROUGH TIME

Paul Hurley

AMBERLEY PUBLISHING

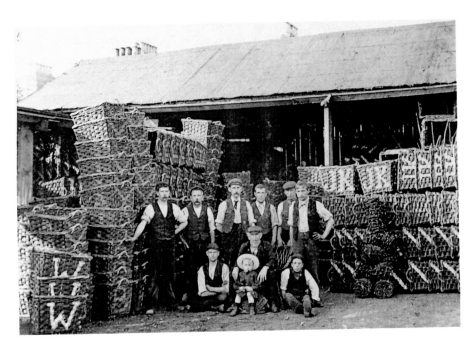

William Bibby had a basket making business at the rear of Church Street and William can be seen in the photograph along with his son also called William, his grandson John and their workers. Bibby's made all sorts of baskets. They had many uses, laundry baskets, railway and potato hampers to name but a few, I remember well those halcyon days of old when potato picking did not involve complicated machinery. Instead a basket would be dragged up and down the field slowly filling with new potatoes that the tractor driver kindly uncovered and spread around with the twin spinning forks on the back of the tractor.

First published 2010

Amberley Publishing Plc
Cirencester Road, Chalford,
Stroud, Gloucestershire, GL6 8PE

www.amberley-books.com

Copyright © Paul Hurley, 2010

The right of Paul Hurley to be identified as the Author of this work has been asserted in accordance with the Copyrights, Designs and Patents Act 1988.

ISBN 978 1 84868 873 5

British Library Cataloguing in Publication Data.
A catalogue record for this book is available from the British Library.

Typeset in 9.5pt on 12pt Celeste.
Typesetting by Amberley Publishing.

Printed in the UK.

Introduction

This book, *Frodsham and Helsby Through Time*, looks at these twin villages through the ages or rather Frodsham Town and Helsby Village. Each has its adjoining hamlets, Five Crosses, Netherton and Overton to name but three. Situated between the forest of Mara and Mondrem, that huge expanse of vegetation, now called Delamere Forest and the river Mersey. The Manchester Ship Canal later joined by the M56 motorway, both straddle the Frodsham Marshes like the cuts of a sabre, each a form of transport that represents different periods in time but both heading purposefully towards the very heart of Manchester.

But let us drift back to the time of William the Conqueror who gave Chester to the ruthless Hugh Lupus to govern. Chester was the centre of power whilst the bishops held the church lands and eight castle strongholds were built to protect mother Chester, Frodsham was one of these and the castle lasted until 1654 when, on the same night as the death of the owner, it burned to the ground. Over the years wars raged, Vale Royal Abbey was built and Delamere forest was converted to a royal forest for the King's diversion! The first Master Forester appointed by King Edward was Ralph de Kingsley of Frodsham. A position that grew into supreme importance, his duties were to preserve the game, attend the noble huntsmen and produce timber for building purposes.

Enough of ancient history, our journey today takes us from the 1840s, the earliest days of photography, to 2010. Each historical photograph is matched with a modern one starting at the very beginning with a photograph of lower Main Street taken in 1842. Then there is the Bulls Head pub, this ancient pub near the church in Overton can trace its licensees back to 1794 when William Woodward was the landlord. A building however has stood on this site since the Domesday Book was compiled. Further down the even older Ring O'Bells where in 1768 the appropriately named Alice Frodsham was the landlady, these pubs still welcome customers today. From this evocative picture we travel through these ancient towns and see what they looked like many years ago and what time has left of the original structures, if anything.

Frodsham Hill, also known as Overton Hill or Mersey View welcomed people of all ages to its pleasure grounds dating back to the simple tearooms of the 1860s and culminating in the more sophisticated entertainments of the 1950s and '60s. The pleasure grounds may now have gone but the view across the Mersey is still there and the many hill top pathways make it a magnet for walkers and picnickers. The war memorial that stands proudly on the top has the most breathtaking views from its sandstone base.

The ancient Frodsham parish church of St Laurence at Overton has the dubious honour of once having as its vicar the man who demolished the tourist attraction that was William Shakespeare's house and chopped down the tree that the famous playwright planted. For his sins he was driven from the town and not only was he banned from ever returning but so was anyone bearing his name! Helsby has its own hill and it was once the site of a hill fort, Neolithic artefacts have been found there and its sandstone was once mined and transported around the country. Helsby Quarry Local Nature Reserve is now in existence with its rock faces, a tunnel, woodland and meadow to explore.

So enjoy this area and have a nostalgic tour with this book as your aid, look with a tinge of sadness at the many beautiful black and white thatched cottages that have been swept away in the name of modernisation. Cottages that could have been modernised but left as an aesthetically pleasing sight to entrance the viewer, see how buildings have changed and see what has replaced those that are no longer with us. Above all, enjoy the book as I have enjoyed compiling it.

Acknowledgements

I would like to thank Cheshire West and Chester Council for permission to use a selection of old photographs from their archives and Mike Edison of the Record Office for his invaluable help and advice. I would also like to thank John Smith, Alan Shaw and Beryl Makin for the loan of photographs. The managers of the Cheshire Cheese, the Helter Skelter, the Netherton Hall and The Railway for offering to or allowing me to use photographs from their walls. To Adele Teasdale for permitting me to take a photo from her bedroom window! I am extremely indebted to Mrs Dorothy Smith whose knowledge of Frodsham is second to none and likewise her sons John and Nick, especially John who gave up his valuable time to accompany me on photographic expeditions and without whom I would have found it difficult to pinpoint the location of the old photographs. Finally I would like to thank my wife Rose for her patience and understanding during the long lonely days that she endured whilst I was photographing, researching and compiling this book.

About the Author
Paul Hurley is a freelance writer and author who has a novel, newspaper, magazine and book credits to his name. He lives in Winsford with his wife and has two sons and two daughters.

By the same author

Fiction
Liverpool Soldier
Non-Fiction
Middlewich
Northwich through Time
Winsford through Time
Villages of Mid Cheshire through Time

www.paul-hurley.co.uk
paul@hurleyp.freeserve.co.uk

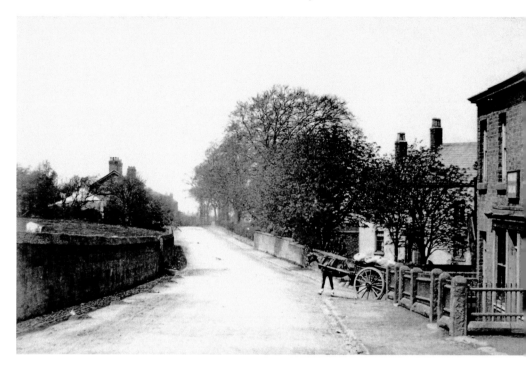

Five Crosses Hamlet early 1900s and 2009

As we travel towards Frodsham from Cuddington and pass the Lady Hayes Craft Centre we enter the hamlet of Five Crosses on Kingsley Road. This hamlet extends down to Vicarage Lane and here in the old photo a pony and cart stands at the Watery Lane junction. The large Goldthorps bakery premises before the junction have been swept away but the house across it is still there. On the other side of the road a cow peeps over the wall at the photographer!

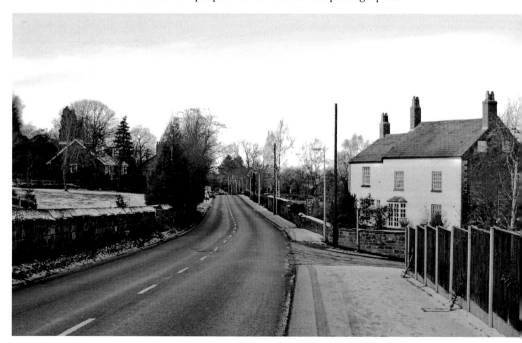

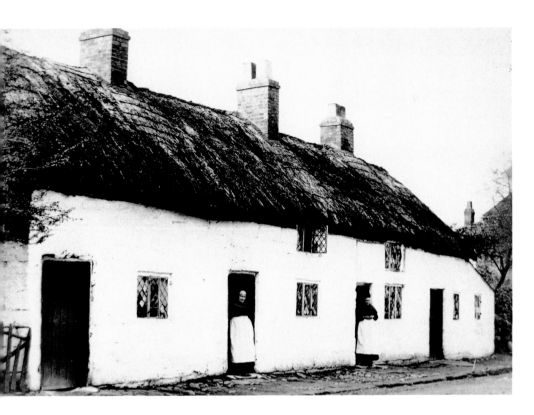

Old Cottages Five Crosses, 1880s and 2009

We continue through Five Crosses and this 2009 view is of two substantial houses which the old photograph shows us were once four small thatched cottages. The lady residents have come out to watch the photographer as he sets up his cumbersome photographic equipment. They are dressed in period long black dress and white pinafore and one wears the black headdress made popular by the mourning Queen Victoria.

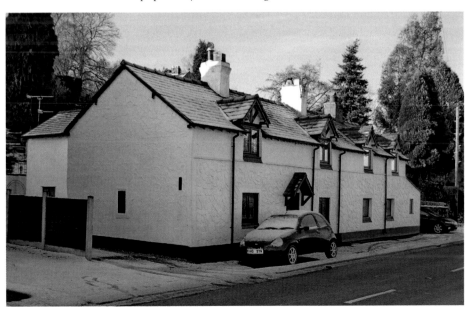

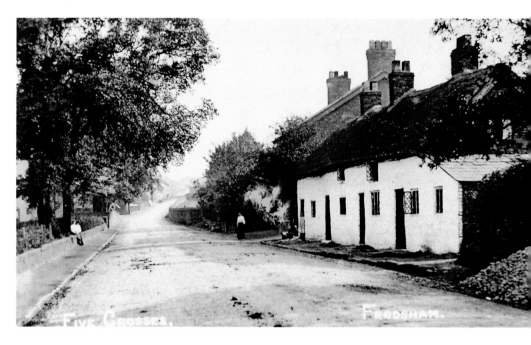

Old Cottages Five Crosses from the opposite direction 1900s and 2009
Looking back now in both time and direction and we see the same cottages, the road we have travelled leads away in the direction of Kingsley and Norley with the Travellers Rest pub just around the far bend. The vista from the front of the cottages, then as now gives an unhindered view across the Weaver to Aston and Dutton and again ladies look on. How different life was then as the smell of wood smoke, countryside and horses filled the air.

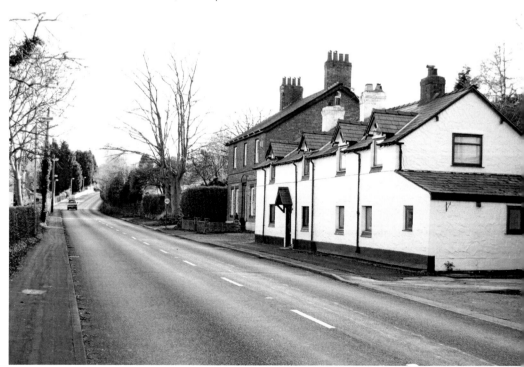

Onwards through Five Crosses 2009 and undated
Here we continue our journey towards Frodsham with the entrance to what was Eversleigh House and is now Warren Court on the left. The large house in the far right is still there and the smithy can just be seen in the distance.

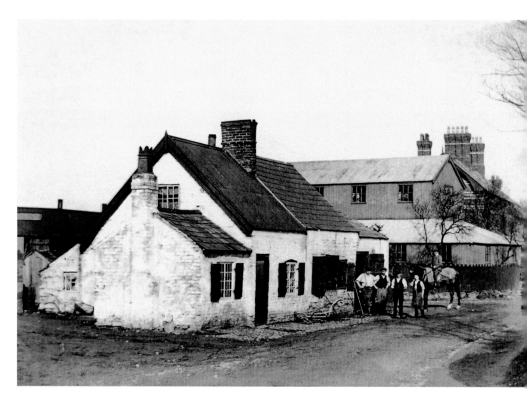

Five Crosses Smithy 1890 to 1914 and 2009

This atmospheric photograph is dated before 1914 as it shows the smithy that once stood at the junction with Manley Road. The proprietor was Frederick Houghton and next to the smithy is the wheelwright's workshop owned by Joseph Berrington. As early as 1860 Joseph and Richard Berrington carried out the trade of wheelwrights, but then they were in Church Street Frodsham. In 1902 Berrington & Sons continued the business but by 1914 only the smithy was left.

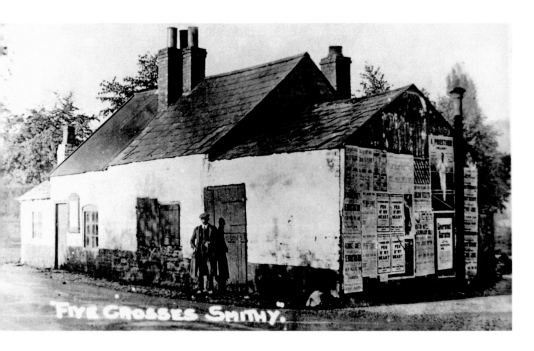

Five Crosses Smithy 1920s and 2009
The smithy now looking from the opposite direction had become somewhat dilapidated by the 1920s and its days were numbered; in 1927 it would be demolished for road widening. Many adverts adorned the walls to attract the travellers leaving Frodsham. One of such advert is for the silent movie *Peg O' My Heart* released in 1922. The area is now simply the junction of Manley Road and Kingsley Road.

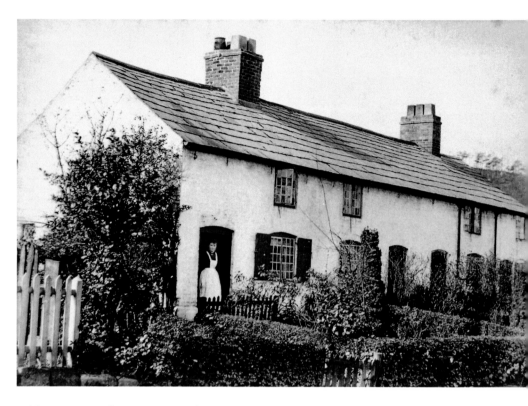

White Cottages Vicarage Lane early 1900 and 2010
This pretty row of white cottages is still there although modernised into one large house and partly hidden in foliage. It is on a bad bend on this busy road but fortunately still has its own access drive.

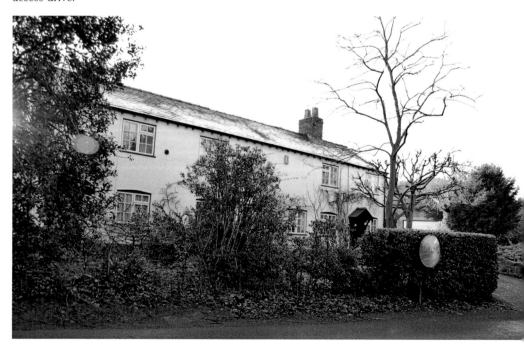

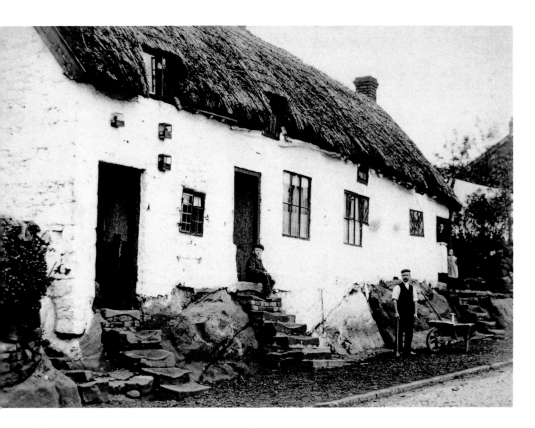

Whitehall Cottages Church Street early 1880 to 1900 and 2010
This cottage was situated at the junction of London Road and as can be seen in the later photo, it was felt more expedient to build new houses on the site than to modernise and retain this piece of Frodsham history. On the wall can be seen three linnet boxes. These were birds caught on Frodsham marshes and kept as songbirds. How many feet have trodden those steps over the years to wear them down like that?

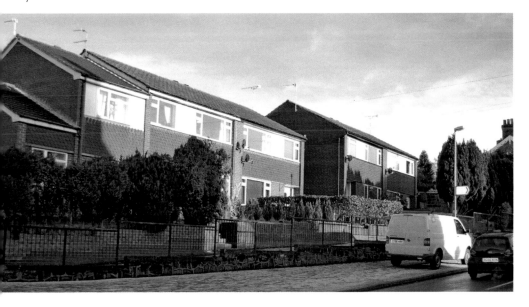

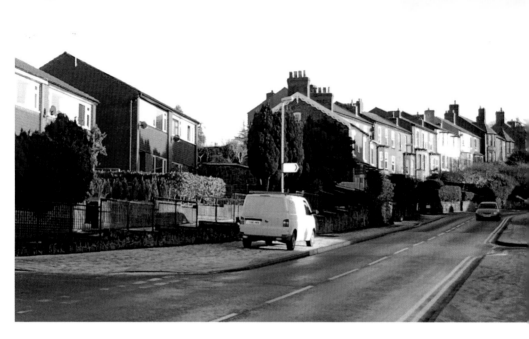

Church Street 2010 and 1920s

A last look now back up Church Street towards Kingsley with Whitehall Cottages to the left. The old photograph was taken around 1910 to 1920 with the ladies in their finery and a rare period car ascending the hill.

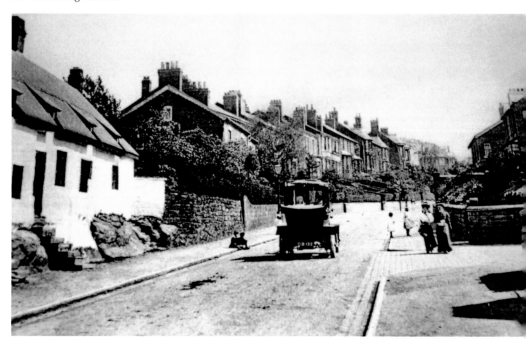

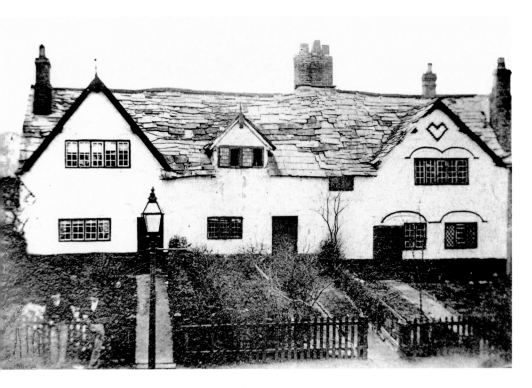

Church Street Shopping Centre 1860s and 2010
Continuing into Church Street we find a modern shopping centre set back from the road. How different this area was in the late 1860s with these large much-altered houses set back from the road. They were situated about where the frontage to the shopping centre is now and were demolished in the 1960s. Eventually the shopping centre was built on the site.

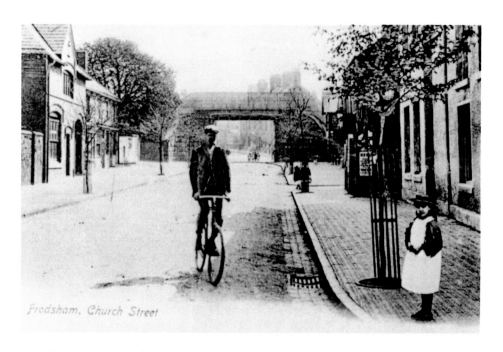

Church Street 1910 and 2010

A view now back up Church Street towards the railway bridge, the newly planted trees date the old photograph to the turn of the century, and as can be seen, some of these trees still exist. The pub on the right is the Golden Lion which dates from 1822 and has the front door in High Street, until 1845 it was called the White Hart.

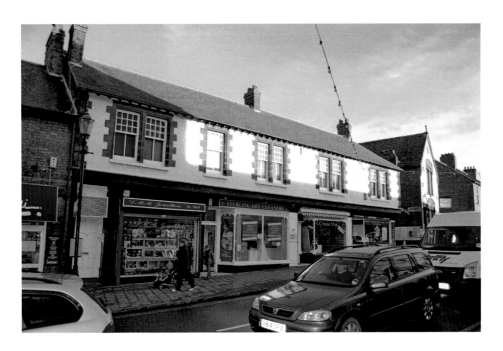

Site of Collinson's shop, Church Street 2010 and 1890s

A more detailed look at the row of shops that once included Collinson's, before the shops were built at the turn of the last century a row of dilapidated cottages filled the site and they are seen here with the wall of the pub to the right. It was then The Drovers Arms, and is now the Helter Skelter. This popular pub was named in honour of the famous helter skelter that once dominated the Overton Hills pleasure ground high on the hill above Frodsham.

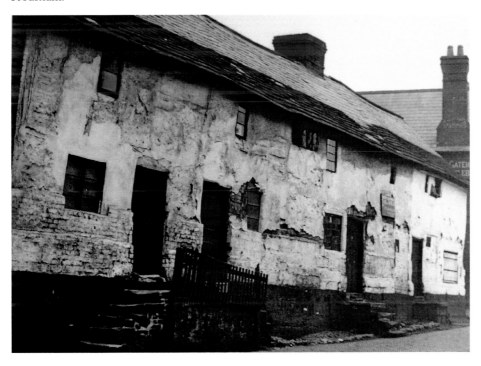

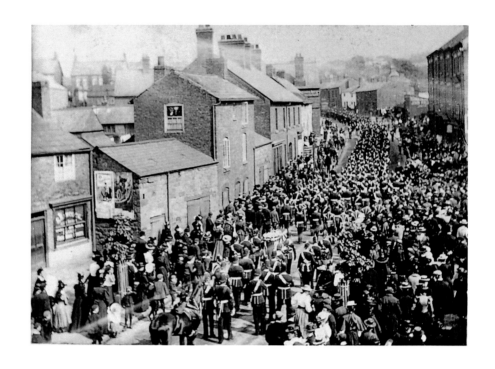

Funeral in 1889 and 2010

In this and the next pair of photographs we see the funeral of Colonel John Ashton, the Commanding officer of the 2nd Cheshire Rifle Volunteers who died in 1889 aged sixty years. The cortège is passing up Church Street with the old cottages on the previous page still there. These ancient cottages only had another nine years to exist.

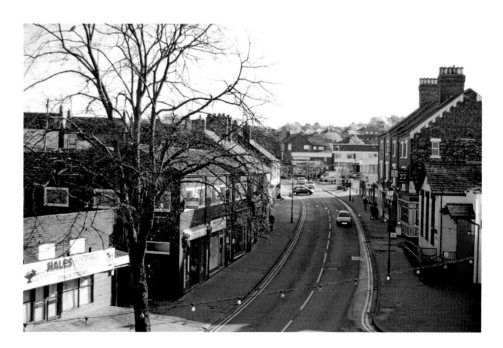

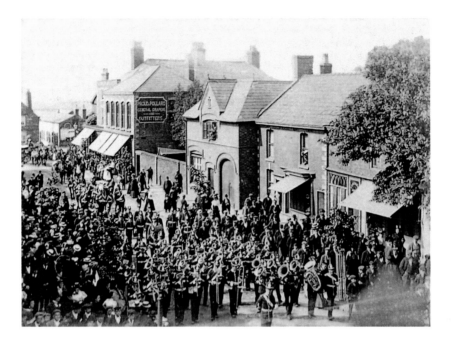

Church Street Funeral 1898 and 2010

Here we have another look at the funeral of Colonel Ashton, this time from the opposite direction and again taken from the railway bridge. The 2nd Cheshire Rifle Volunteers, part of the Volunteer Corps, were introduced in 1859 under the auspices of the Volunteer Act 1804 and served with distinction throughout the world's trouble spots. The popular pub name 'The Volunteer' originated here. In 1863 the 1804 act was replaced and the Volunteers came under the wings of the Cheshire Regiment.

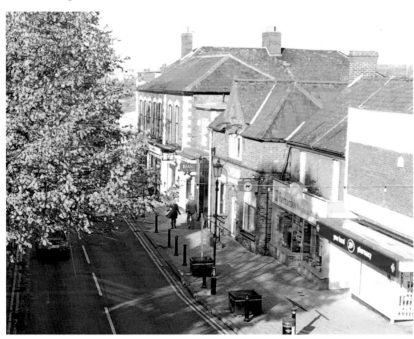

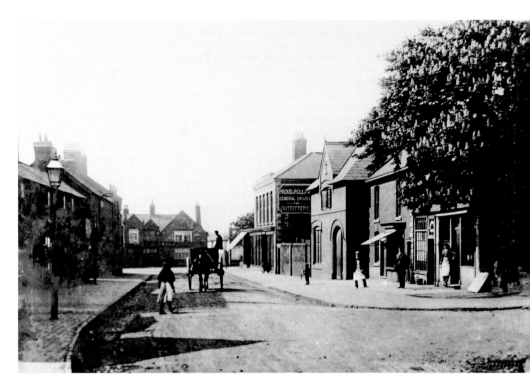

Church Street 1890 and 2010

Another look down Church Street towards the Bear's Paw with Proud and Pollard drapers to the right, little has changed over the years, Proud and Pollard became Pollard Brothers and the building was extended onto the land that the wall hides in the old photo. A more modern shop has replaced the old one at the road junction leading to the station and a supermarket.

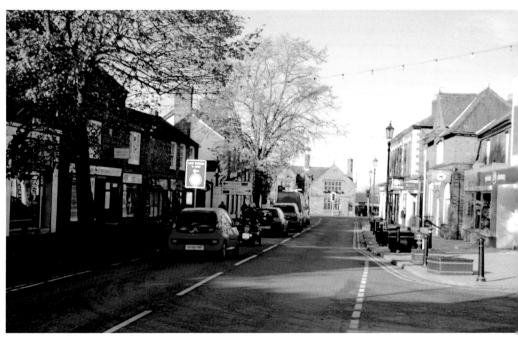

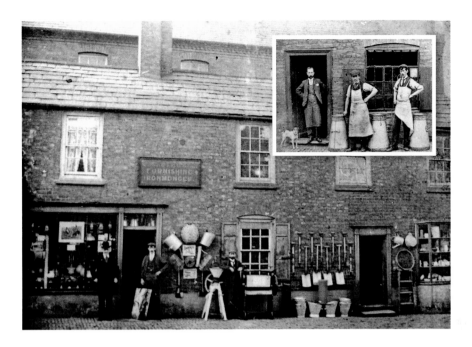

Rothwells Shop Church Street 1899, 1898 and 2010

When the older photograph was taken this was Rothwell's ironmongers shop and later became Pollard's Ironmongers. At the rear of the premises was Rothwell's workshop in which all manner of metal implements were made. In the inset photograph we see two of the tinsmiths or 'tinkers' with three of their own make milk churns. Mr Rothwell himself stands in the doorway. Happily the building still exists as can be seen in the 2010 photograph; or rather a building still exists (see the next page).

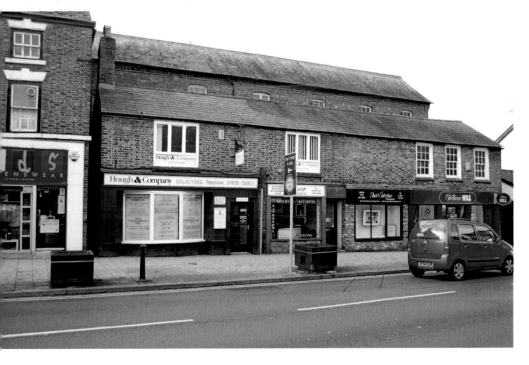

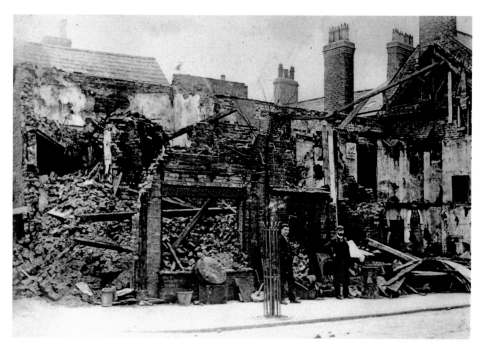

Church Street Fire 1902 and 2010

Rothwell's shop in Church Street caught fire just three years after the 1899 photo on the last page was taken. As can be seen in the new photograph, the building was re-built in exactly the same form as the one that burn down; this was common practice at the time.

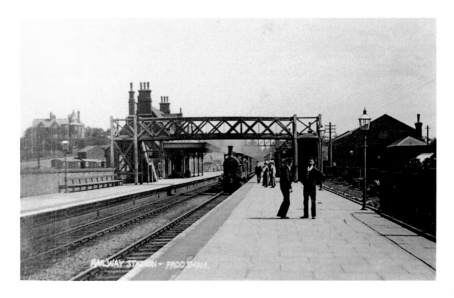

Frodsham Railway Station 1900 and 2010

The line through Frodsham was built in 1862 by the Birkenhead, Lancashire and Cheshire Junction Railway. Later it became the LNWR and the Great Western with connections countrywide but more locally between Chester and Warrington. In the old photograph sidings can be seen on the left with two Great Western box vans therein, now only the station forecourt remains.

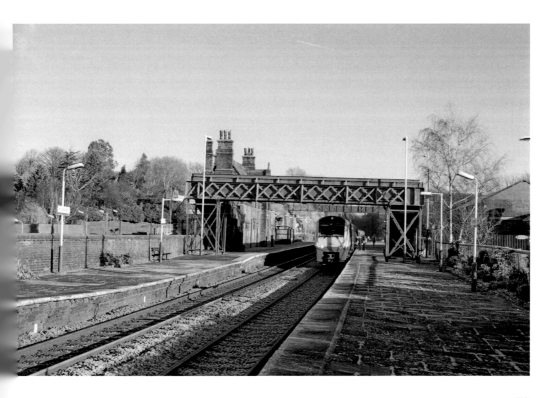

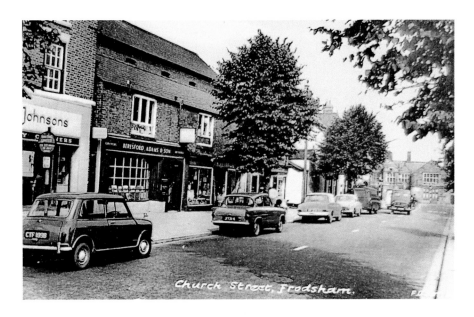

Church Street 1960s and 2010

We now take a last look towards the end of Church Street, this time at the other side of the road during the 1960s. Now the ubiquitous Mini and Ford Anglia have taken the place of the horse drawn traffic. Just out of shot is a rather unique phone box that can be seen in the inset. This self contained post office known as 'The Vermillion Giant' was designed by Sir Giles Scott in 1927 and was only one of fifty made, of which only four examples are known to survive; it is a Grade II listed building.

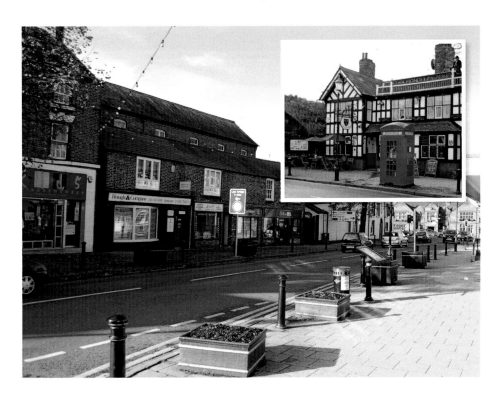

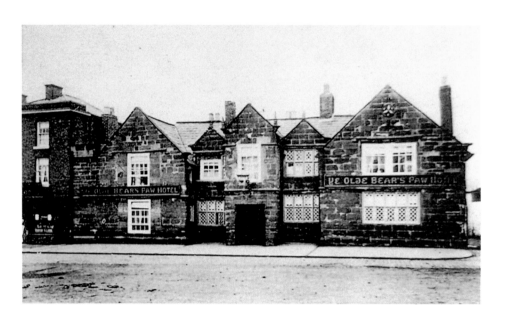

Ye Olde Bear's Paw undated and 2010
No book on Frodsham would be complete without mention of the Bear's Paw. This ancient hostelry with a headstone above the door giving its year of construction as 1632 can trace its landlords back to John Smith in 1784. The post office was once inside the inn and during the 1800s went by the names of The Bear's Paw and Station and then the Bear's Paw and Railway. The old photograph here is from the early days of photography.

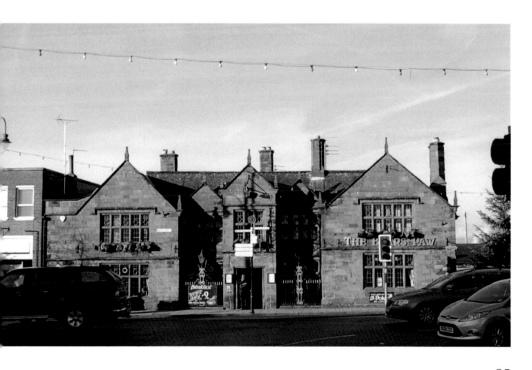

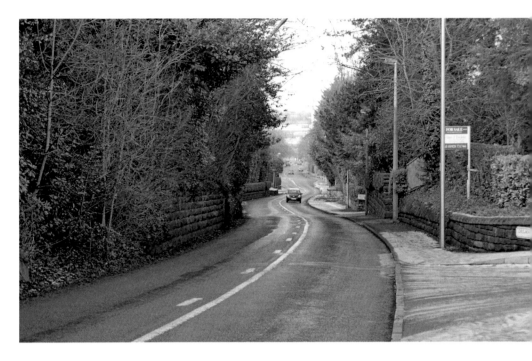

Fluin Lane 2010 and undated
This lane leaves Red Lane and travels through to High Street, once a quiet backwater it now leads to new housing developments. The gateway on the right in the old photograph leads to the house known as Moorcroft.

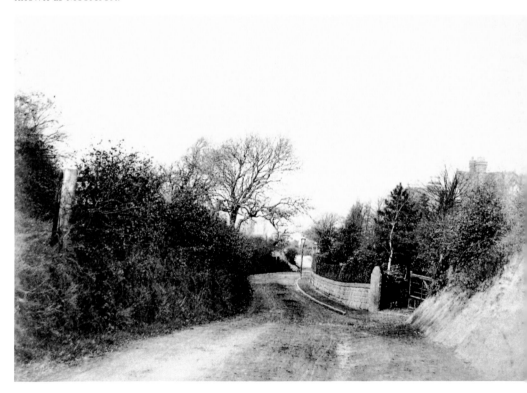

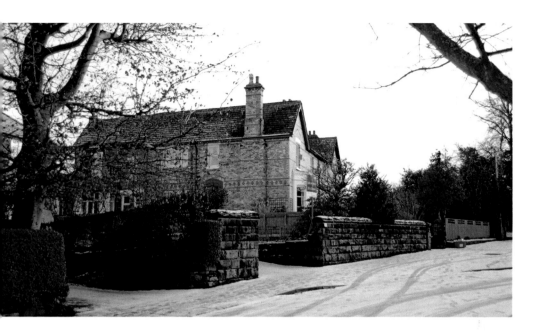

Fluin Lane Gardeners 2010 and early 1900s

Here we see that there has been quite a change at the junction of Fluin Lane and Red Lane with gardeners working on the extensive gardens of Stapleton House. The large house in the photograph is the home of Mrs Dorothy Smith and her family who were a great help with the compilation of this book.

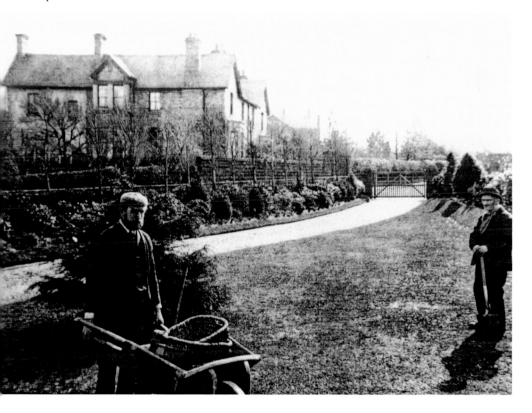

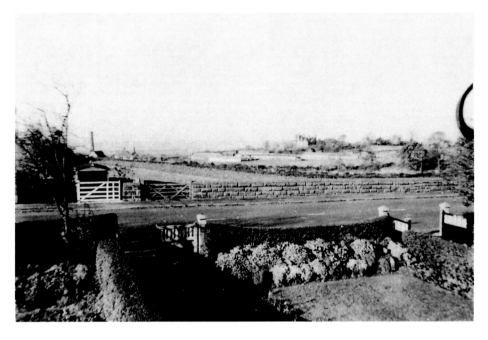

Fluin Lane from House undated and 2010

This private photograph was taken from the bedroom window of one of the houses in Fluin lane and it looks towards the shopping centre and the large chimney in the distance. This chimney served Kydd's Jam Works built in 1891 by J. G. Kydd and demolished in around 1973. Kydd's Grocers in Church Street Frodsham was a large and prestigious shop. The name is preserved locally at Kydd's Wine Bar.

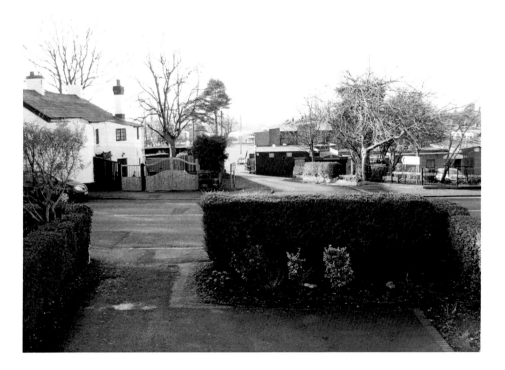

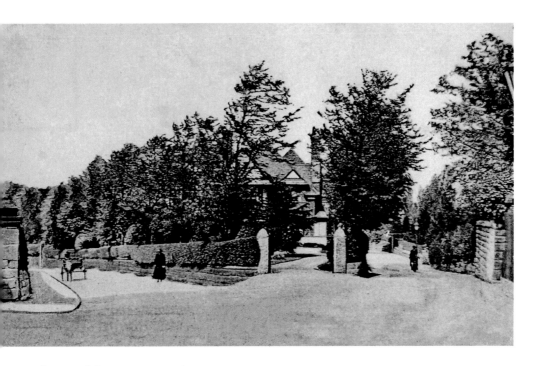

Red Lane–Fluin Lane 1900 and 2010

Here we see the junction as it was in 1900 with the impressive Stapleton House in the centre. This house was only built in 1887 but was demolished in 1959. At the turn of the last century it had housed the Garratt family. The gatepost on the left can also be seen in the new photo and shows how far the Stapleton House gardens stretched towards the camera.

Red Lane 2010 and undated

In this rather poor photograph we look down Red Lane towards Church Street. The large house, Brentwood, on the left is the one shown in the 2010 photo despite looking as if it is up on a bank. It was the home of the well known Frodsham surgeon Dr Harold Blades Ellison who, as well as being the Factory Surgeon was also the Medical Officer during the first war at the military hospital at Bellemonte. It was said that he tended the troops during the night and his local patients during the day. He was later a common sight whilst doing his rounds in his Austin Seven car.

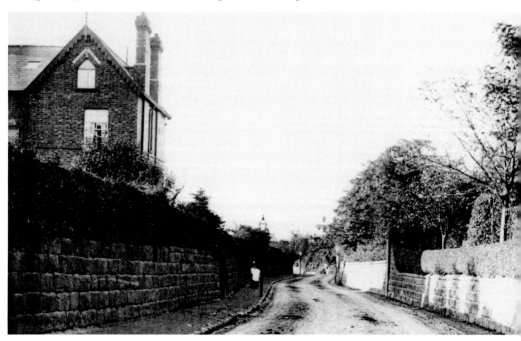

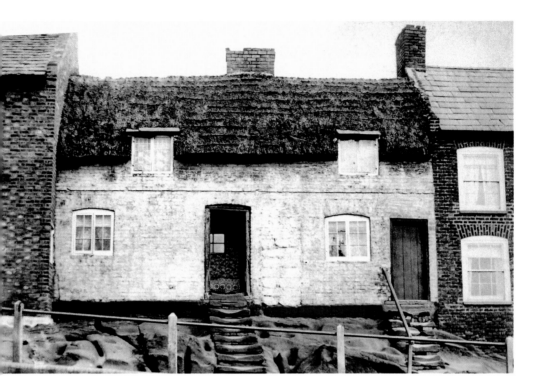

Rock Cottage High Street early 1900s and 2010

Set back from the High Street these cottages, once known as the Fishermen's Cottages, have stood the test of time. The cottages once formed two dwellings but as the new photograph shows, it is now one nicely refurbished house. What a pity that the many other ancient Frodsham cottages could have received the same treatment and not just been knocked down.

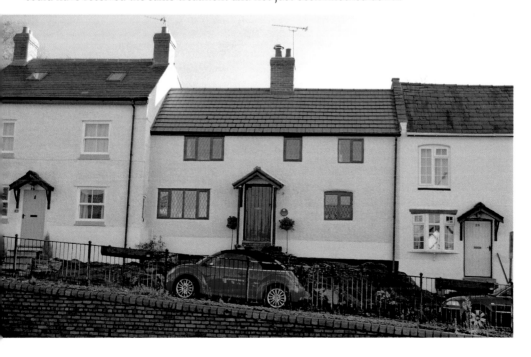

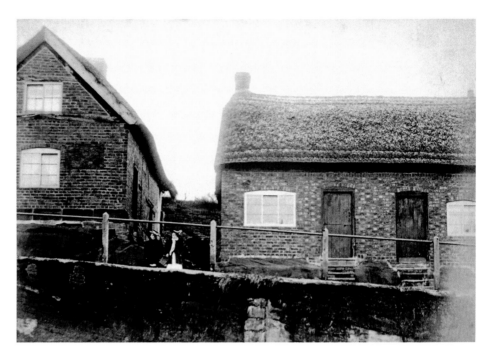

Old Cottage 44 High Street early 1900s and 2010

Another set of cottages on the High Street that have received most favourable treatment and have been rescued from the fingers of the demolition developers. Once consisting of three cottages dating back to the 1600s or earlier, they have been joined together to make one beautiful house. One of the residents around the time of the old photograph was Hannah Hayes who lived in the middle one. The house caught fire in 1920 and her pony 'Porky' sadly died. She was well loved around the town and the locals made a collection and bought her another 'Porky!'

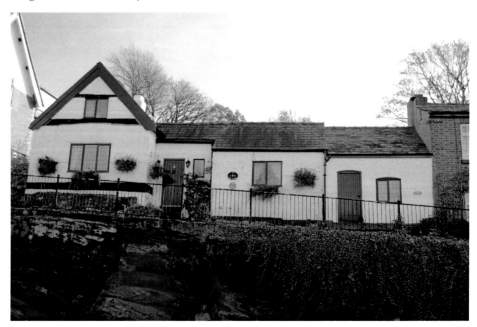

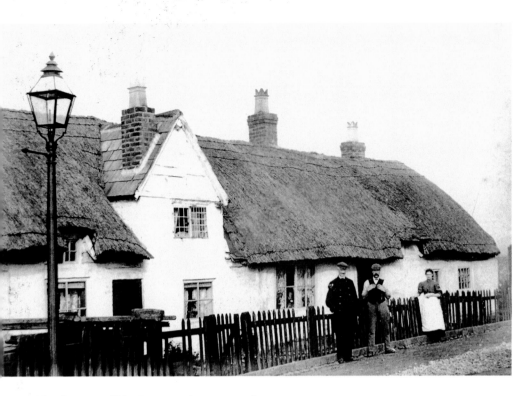

White Cottages Ship Street early 1900s and 2010

Off High Street now and into Ship Street which leads down to the banks of the Weaver. As we pass the police station, a modern and not very pleasing building was erected near to the older one, now vacated, but far more attractive. On the other side of the road is a modern terrace that used to be the site of the pretty black and white building known as 'Weston View Farm.' This was replaced in 1920 by another farmhouse and this in turn has been replaced by the terrace.

Ship Street 2010 and early 1900s

Carrying on along Ship Street we find these houses on the left. The cottage that the young boy, possibly one of the Hayes family who once lived there, is standing outside has gone and been replaced with the most ugly length of rusty corrugated iron. At the time of writing proposals were afoot to build on the site. What a pity that the cottage did not receive the same treatment as those on the rock!

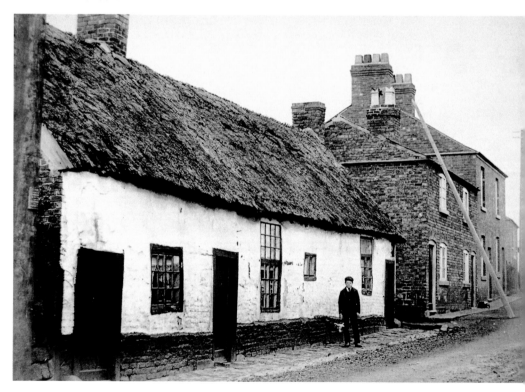

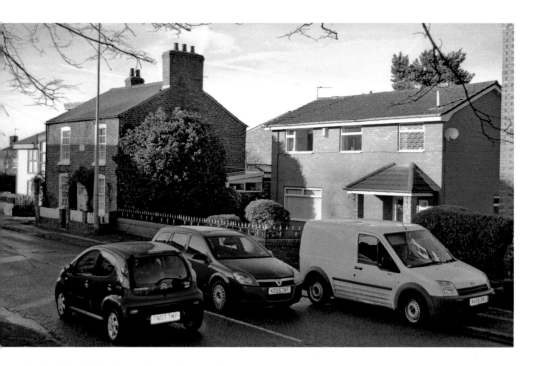

Rock Villa High Street late 1800s and 2010

In the old photograph we see a small cottage with a corrugated iron roof that abuts the house that is still there. This small cottage once housed a family of seven and the father John Willie Percival was a chimney sweep and fireman. The adjoining cottage still has its thatched roof and the lady of the house stands proudly at the door as she and the bearded gentlemen watch the cameraman. In the modern photo the cottages have gone and no one is interested in the photographer!

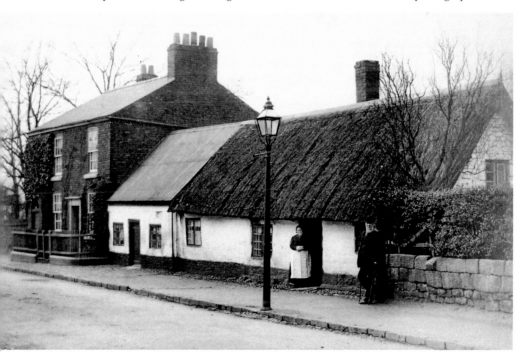

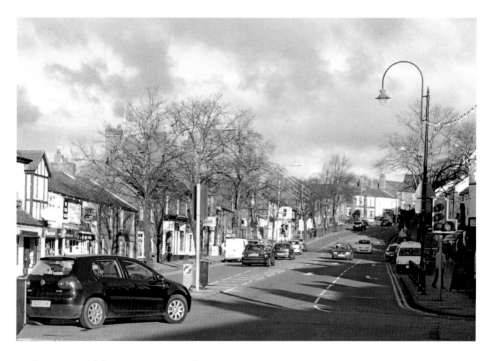

Main Street–High Street 2009 and 1915

At the junction with Church Street we look towards High Street and onwards towards Runcorn. The vista is the same albeit that the modern photo was taken from slightly further back. The dray and lorry in the old photo was once a common site on our roads, and with such quiet roads the driver felt comfortable making his leisurely way down the centre of the road.

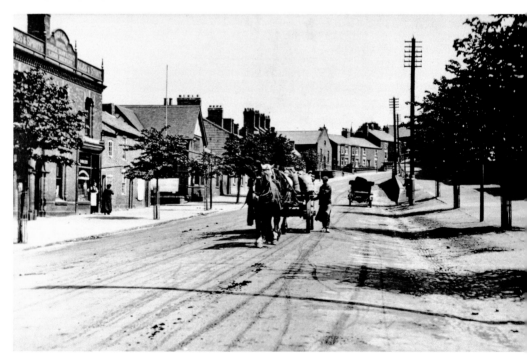

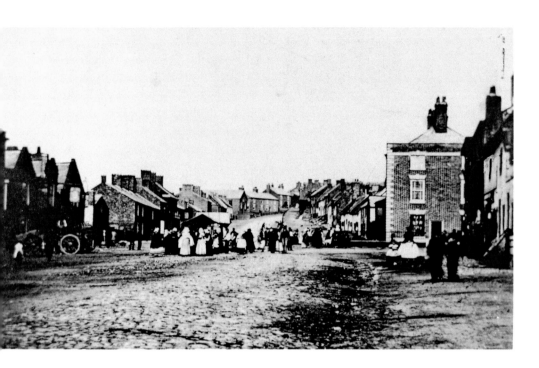

Main Street–High Street 1860 and 2010

This is another of our truly ancient photographs; the old one was taken in 1860, a period at the dawn of photographic development, it was probably taken using a dry plate and a large cumbersome camera. The shot depicts the old butter market at Frodsham and as the new photograph – taken with a hand held Nikon D40 digital camera shows, the market was in the centre of the road at the Church Street junction. Oh, how things have changed!

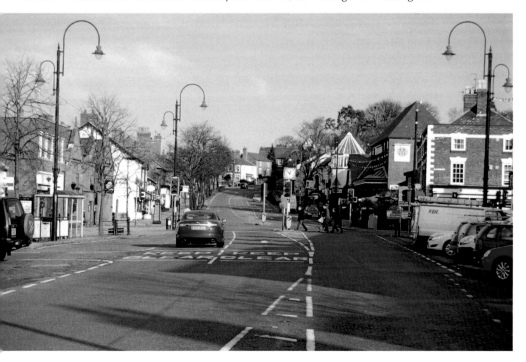

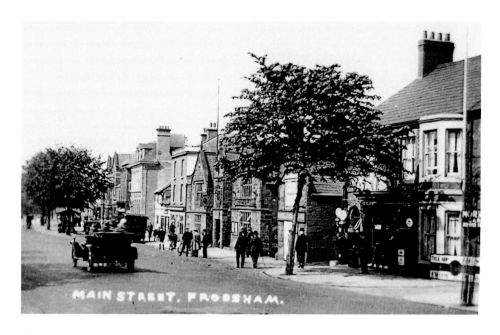

Main Street 1915 to 1925 and 2010

A nice period shot of the front of the Bear's Paw as a modern car passes, well, modern for the period and quite new. Near to the camera on the right and prior to the now demolished small building that went to widen access to the pub car park, we see a garage and petrol station with petrol pumps. This building now houses the Devonshire Bakery, purveyors of the most exquisite pastries and one of Frodsham's hidden gems.

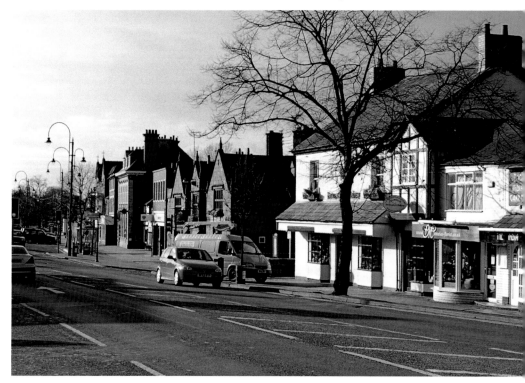

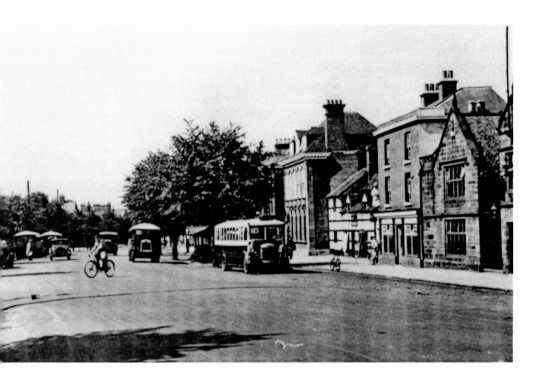

Main Street with Buses 1930 and 2010

From a similar location to the last but forward in time to the 1930s, here we see buses leaving Main Street for the wilds of Cheshire and elsewhere. This most popular form of transport is highlighted by the fact that there are a five such vehicles in the shot, the majority will be from the Crosville Company.

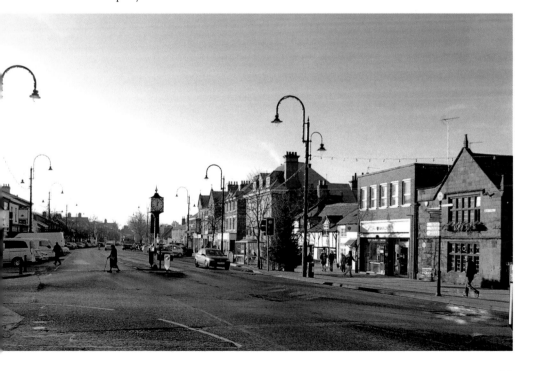

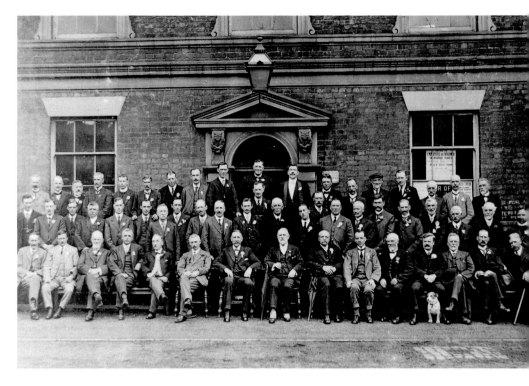

Main Street Peace Celebrations 1920 and 2010

This old photograph taken in 1920 of the Peace Celebrations Committee sitting in front of the Town Hall; the war ended in 1918 and after this came the many tasks needed following such a period of strife. By the 1920s it was time to sit back and relax, to build war memorials and hold celebrations and this is what Frodsham did during this year. The Town Hall is now the Lloyds TSB bank as can be seen in the modern photograph.

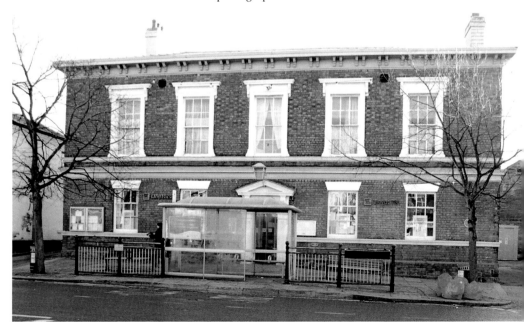

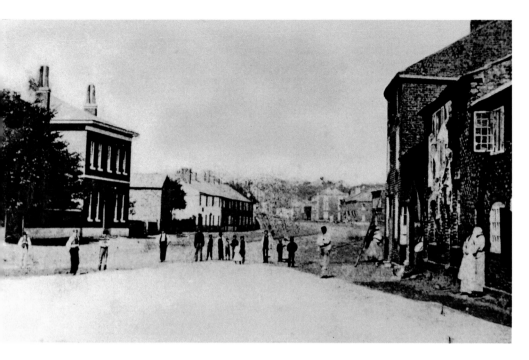

Main Street 1856 and 2010

Back now to the beginnings of photography with an apology for the quality, but with a good reason! Taken in 1856 from the Helsby end of Main Street we see that there has been change but much is still there. On the right of the picture is the Tan Yard and it has cow hides hanging to dry.

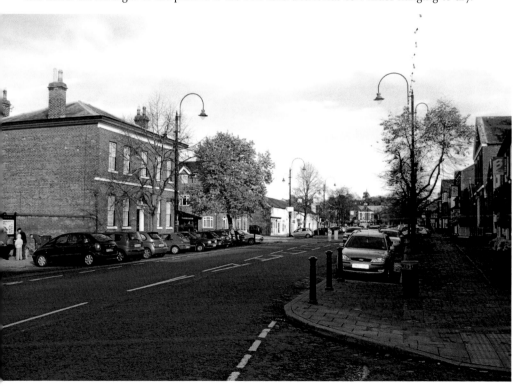

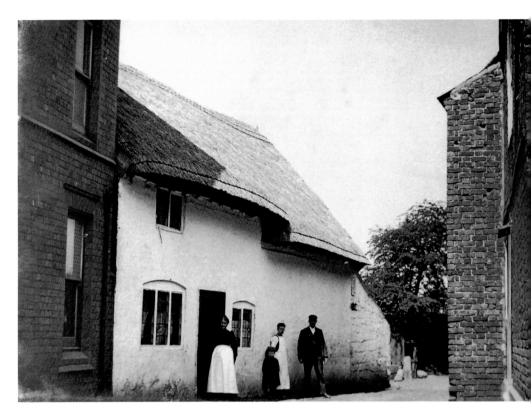

Off Main Street early 1900s and 2010
What worse ignominy could this pretty cottage in Moor Lane have suffered than being knocked down and eventually replaced by a public toilet? But that is what happened, the large building that abuts it is still there but the pretty thatched cottage has gone – no more to be said!

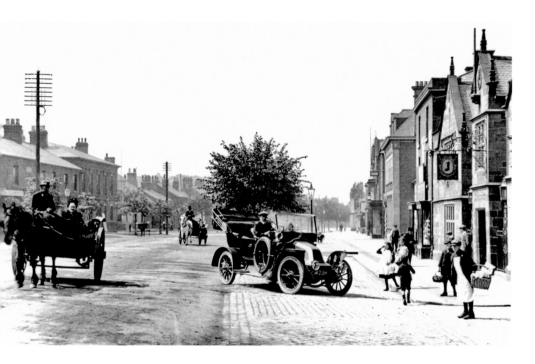

Old Car, Bear's Paw 1910 and 2010

Here a rather new looking De Dion Bouton car turns into the Bear's Paw whilst a pony and rather heavy trap pass by with an old lady passenger. Further back is a horse drawn carriage; this form of passenger transport saw their days numbered then, although the goods versions had a further forty years to go. Watching the camera is a bread delivery boy with his basket of goodies, would he come through the Great War safely do you think?

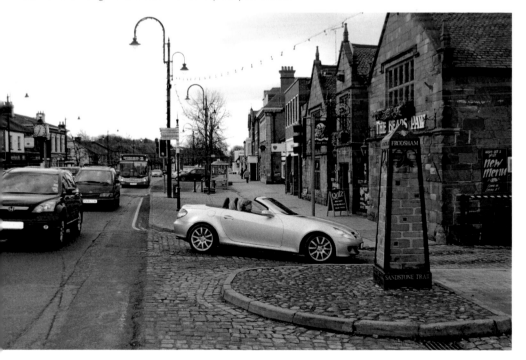

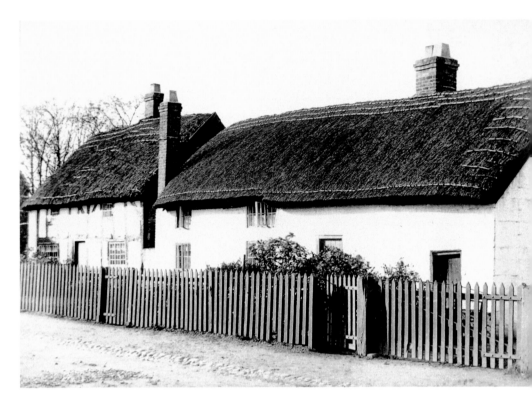

Lower Main Street 1900s and 2010

These two cottages have now gone to make way for that shown in the modern shot; the long cottage was home to the Bromley family and was demolished in 1926. The half-timbered house on the left was demolished in 1960 and was home to the Smith family.

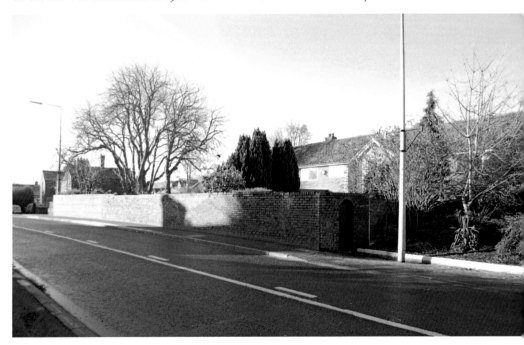

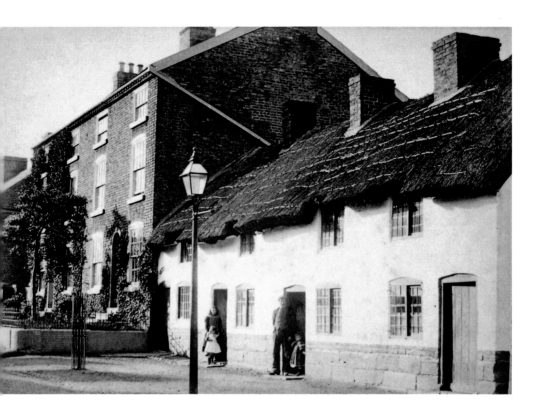

West Bank Cottages Main Street early 1900s and 2010
Still in the same location we find a large house still as it was over 100 years ago, the gable end of the building on the far left is the Cheshire Cheese pub. The three cottages have gone to make way for the rather unattractive brown house. How cosy those cottages will have been with crackling wood fires feeding those sturdy chimneystacks, but the brown house with its central heating will be comfortable in its own way.

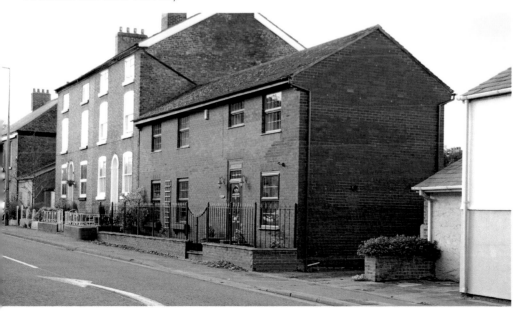

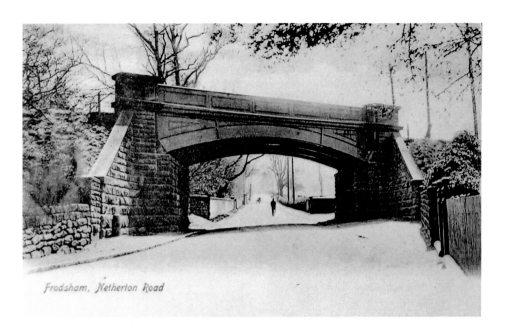

Frodsham, Netherton Road

Chester Road Railway Bridge early 1900s and 2010
This bridge carrying the railway between Frodsham and Helsby was erected when the railway was built in 1862. It was constructed in cast iron and remained there until 1922 when it was replaced. It was again overhauled in the 1960s and the latest transformation can be seen in the modern photograph. The brickwork however has remained the same.

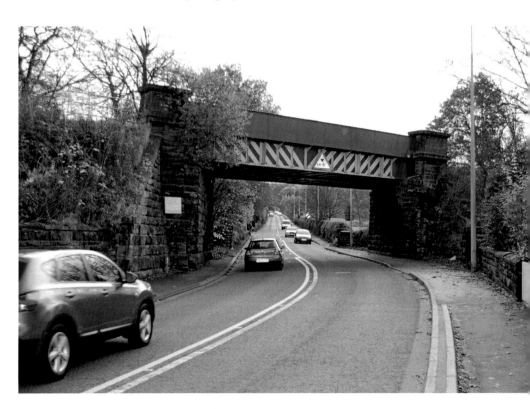

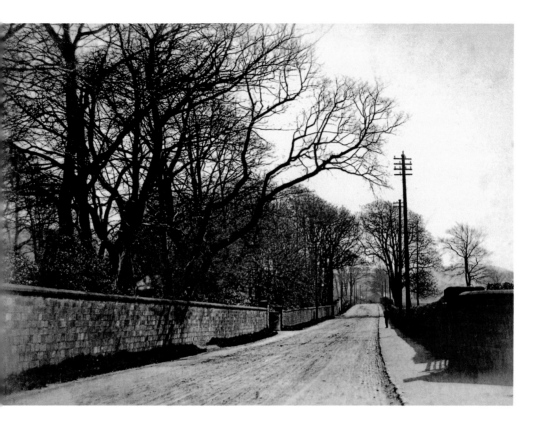

Chester Road 1900 and 2010

We pass under the bridge and observe the view up Chester Road towards Helsby. Little has changed here; the telegraph poles have gone and been re-routed underground. Strangely enough when telegraphy was in its infancy the lines were firstly routed underground and later on poles, mainly utilising the railway tracks. Now they are back underground again.

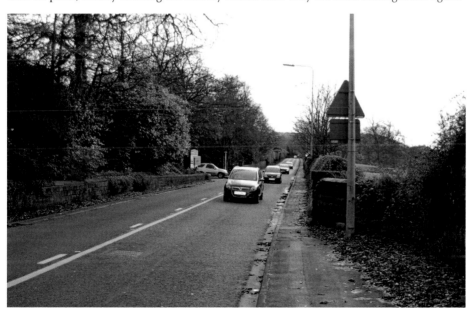

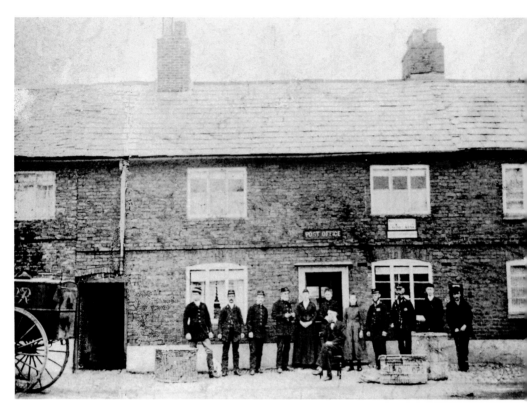

Frodsham Post Office 75 Main Street 1860s and 2010

Back now for another look at the town centre and the main post office, in the 1860s shot we see the staff posing for the camera, the men in uniform with shako hats and the ladies in their black dresses. On the extreme left is a post van with the logo VR with crown between the letters. In the early 1900s the post office was transferred across the road and in the modern photo the building is a house. This photo was quite poor and I had to introduce my artistic expertise to render it acceptable!

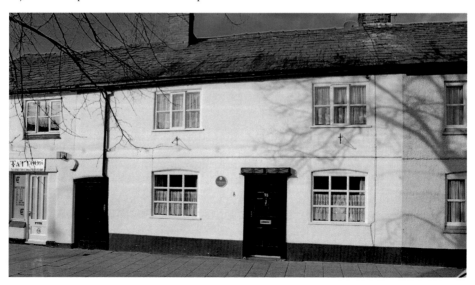

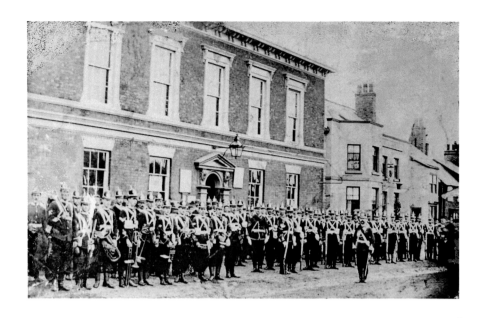

Frodsham Volunteers 1898 and 2010

The soldiers of the 2nd Volunteer Battalion of the Cheshire regiment are seen parading in their best uniforms outside what was then the Town Hall. They would get a new Drill Hall further along Main Street two years later and the gates would be presented by Mrs Garratt of Stapleton House which was mentioned on a previous page. In the modern photo the Town Hall now houses Lloyds TSB Bank. The white building next door is the recently refurbished Queens Head hotel building.

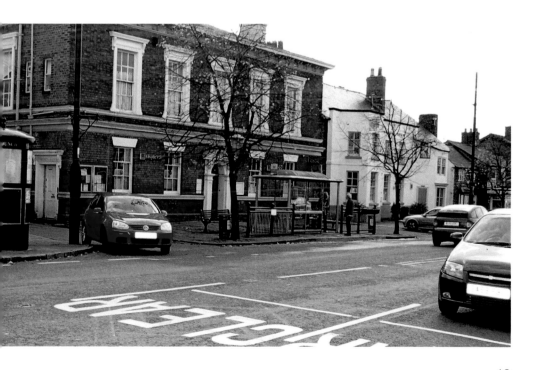

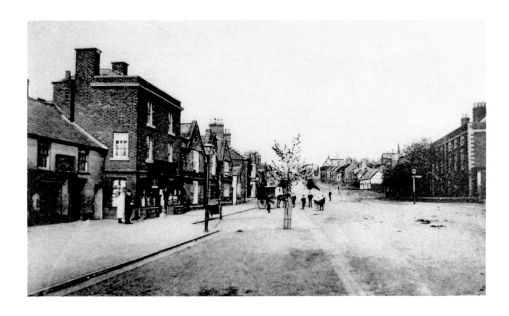

Main Street 1900 and 2010
Now a look back up Main Street towards High Street, the trees within their protective metal frames were planted in 1897 to commemorate the Diamond Jubilee of Queen Victoria. The large house on the right at the junction with Church Street is Crosbie house. It was built in the late eighteenth century by William Crosbie who had been Mayor of Liverpool but re-located to Frodsham during the salt trading boom.

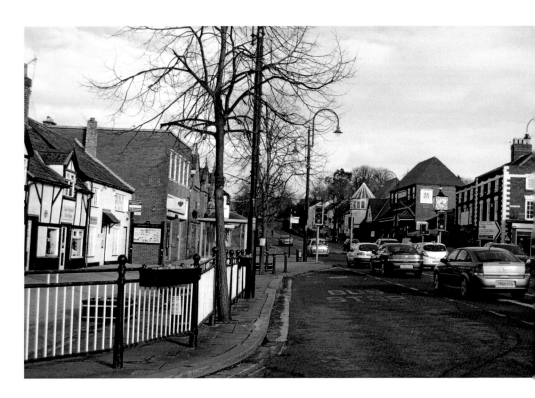

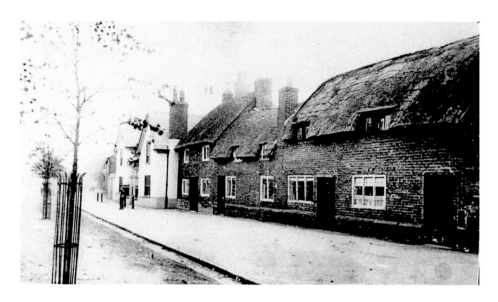

Old Hall Main Street 1900 and 2010

This is how cottages should be preserved; these buildings once contained four cottages built in the seventeenth century. As the new photo shows, they have changed little over the years and what alterations have been done have been sympathetic. In the distance is the Old Hall Hotel which was originally two seventeenth century cottages. During the nineteenth century the buildings were converted to one and the frontage altered. In the rear garden there are two 'tide stones' indicating that the tides reached there in 1802 and 1862.

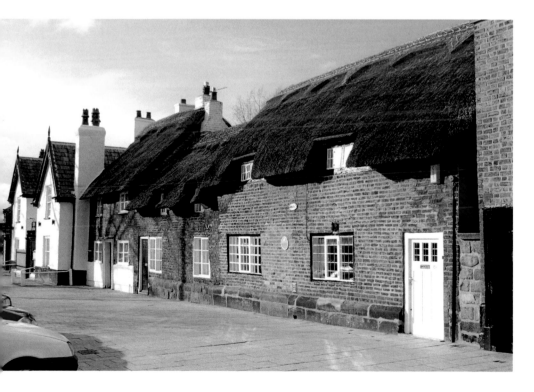

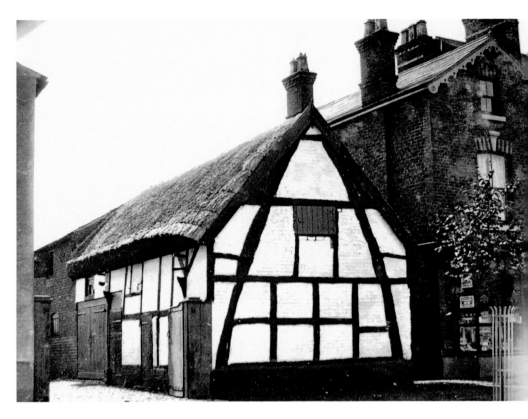

Main Street 1900 and 2010

Crossing the road now we use this old photograph to see just where one of the last Cruck building in Frodsham used to stand. This medieval barn was demolished during the last century and the building shown in the modern photograph took its place.

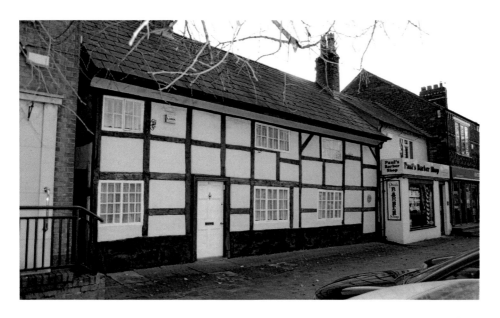

Main Street 1900 and 2010

Another example of sympathetic modernisation, this seventeenth century cottage known as the Old Manor House is on Main Street and stands between the HSBC bank and Paul's barber shop. In the early photo it is thatched but today this has been replaced with tiles, little else has changed.

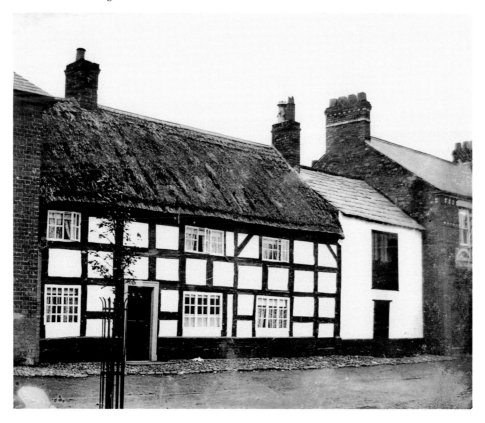

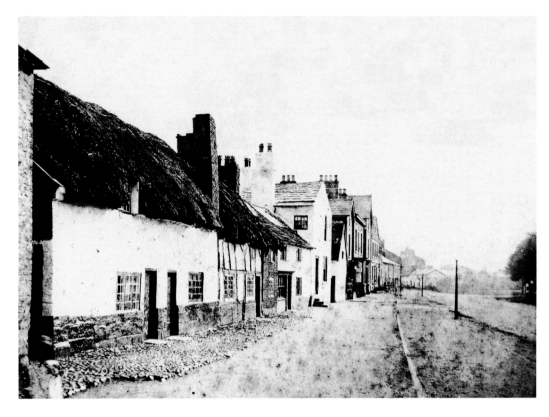

Lower Main Street 1842 and 2010

This is the oldest recorded photograph in the book and the quality reflects this. Taken in 1842, that is 168 years ago! It shows Main Street as it once looked, it also shows that the large white building with the steps down to the footpath is still there as are some buildings beyond it. Not only is it still there but so are the steps.

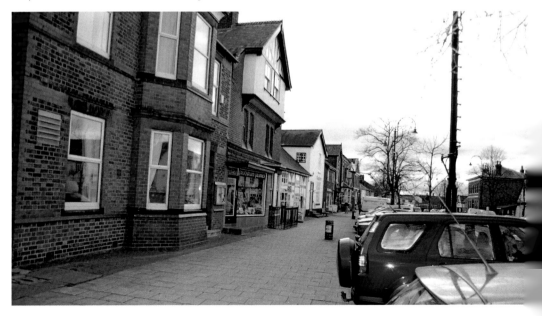

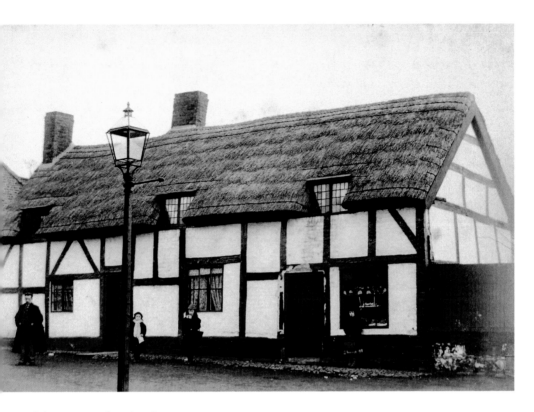

High Street undated and 2010

This old photograph is of a cottage in High Street, it was the home of the Snelson family and Peter Snelson was well known around the town firstly for renting out his pony and trap and later his landau. The cottage was knocked down to make way for a garage and that in turn went when that area of the town was redeveloped and became the Morrison's supermarket.

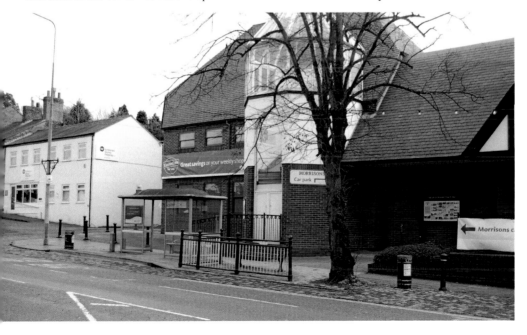

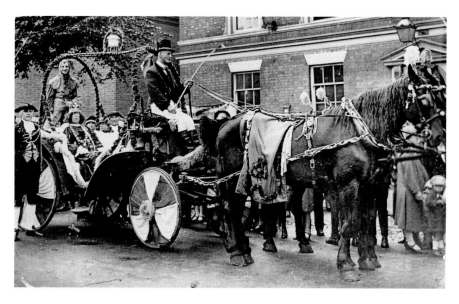

Peter Snelson's Landau in Frodsham Carnival undated and 2010
The old photograph shows Peter Snelson's landau by the Town Hall with his cabby holding the reigns in one of the Frodsham carnivals. The first carnival was in 1926 but Peter's landau was in constant demand for weddings, funerals and other social occasions.

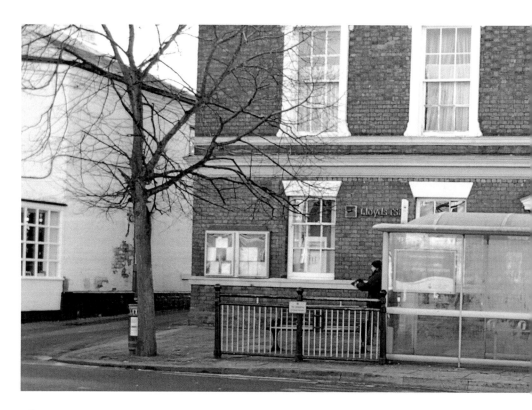

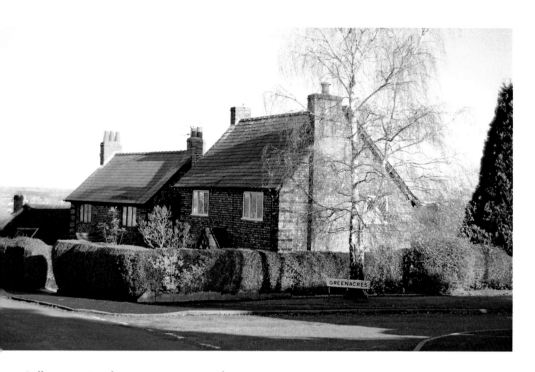

Bellemonte Road 30 January 1942 and 2010
One of two photographs included here to show the heavy snowfall that Frodsham suffered on the 30th January 1942. This house is situated on the bend in Bellemonte Road at what is the junction with Greenacres.

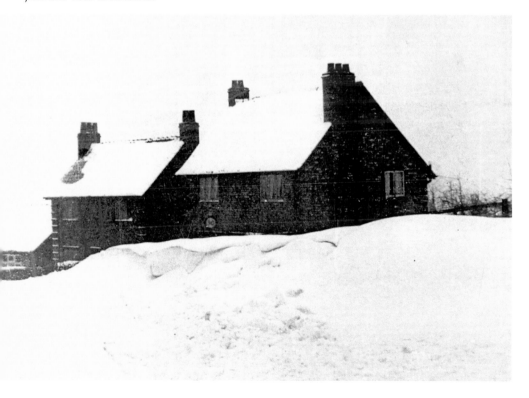

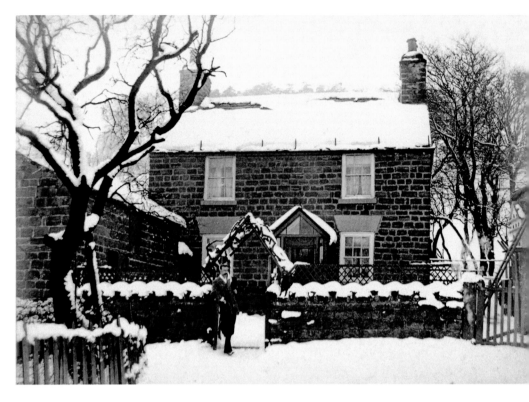

Beacon Farm undated and 2010
On the bend in Bellemonte Road is this farm, it is almost opposite the house in the last caption. Bellemonte, a French word loosely translated as beautiful mounts or rises, the road is a steep hill. This farm has been altered a lot over the years and alterations are taking place at the time of writing. The barn on the left seems to be the most original remaining fabric.

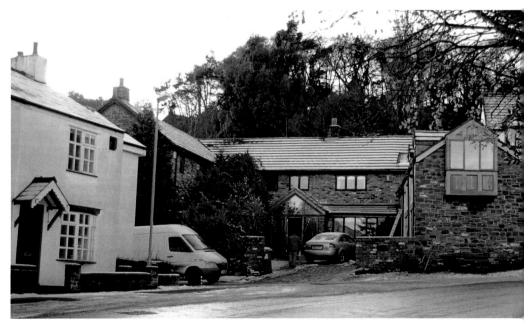

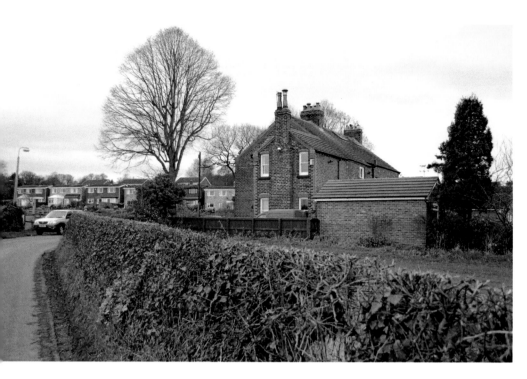

Bradley Lane 30 January 1942 and 2010

Back now to Bradley Lane off Vicarage Lane we see the house on the bend with a man standing in the snow. The house is Ivy Cottage and it was built in 1873.

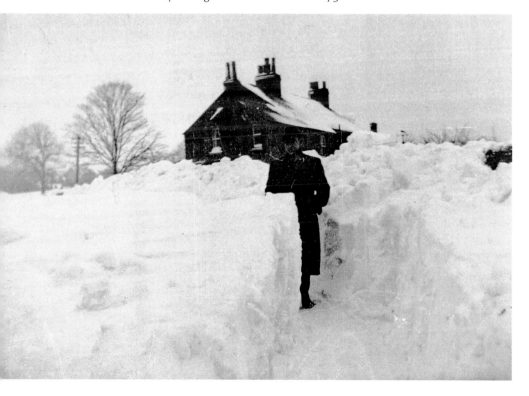

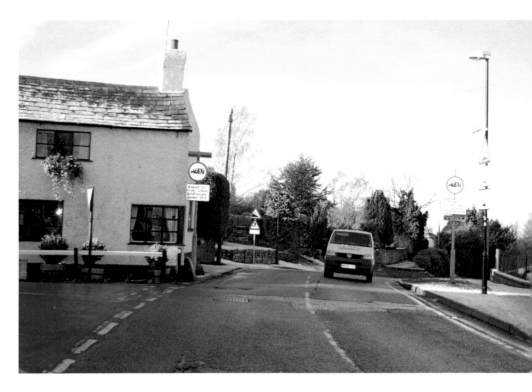

Church Cottages Overton 2010 and 1800s

We now go to the area in which the church of St Laurence stands with a look at the area around the Ring O'Bells Inn and the church. In this old photograph we see what was once between the pub and the church. A vibrant area of old cottages and farm buildings, the cottages on the right have now been swept away to make way for the church car park.

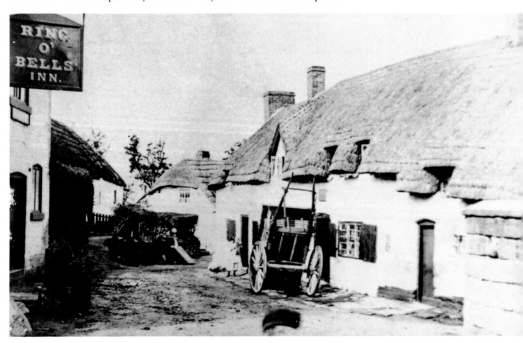

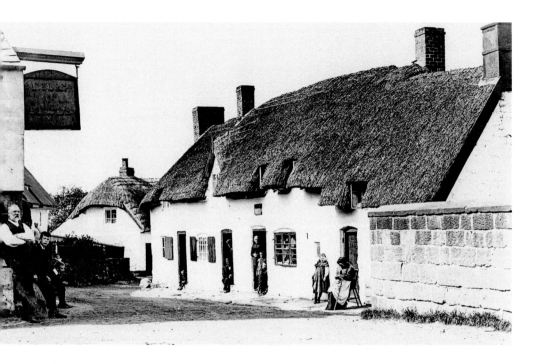

Church Cottages Overton 1900s and 2010

Here we have two shots similar to the last one, both taken within a few years of each other but interesting for their look at the antiquity of the area. The lady standing in the doorway nearest the camera is quite possibly Betty Mercer whose sweet shop it was. She was well known locally for her humbugs!

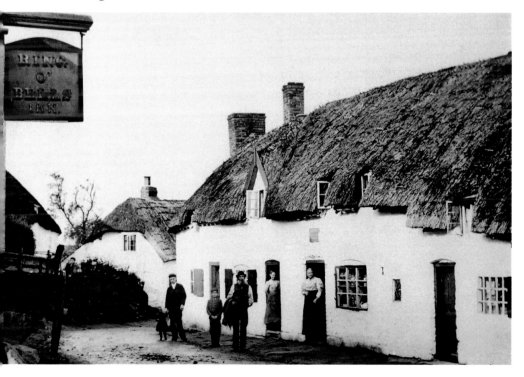

School Lane Overton Village 2010 and 1900
Something of an optical illusion here as we are in fact looking up hill as we stand in School Lane, in the old photo it looks as if we are looking down! Hawthorn Cottage at the end has gone; it burnt down in the 1930s and was later replaced by the current building which now houses the Overton Village Stores.

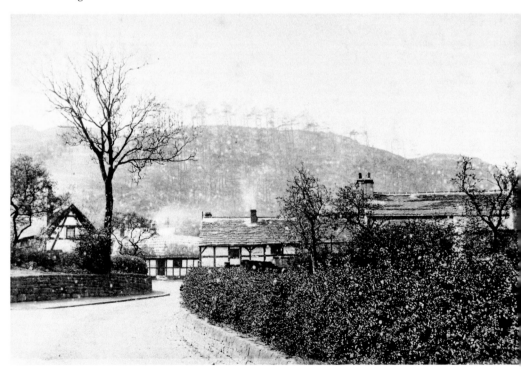

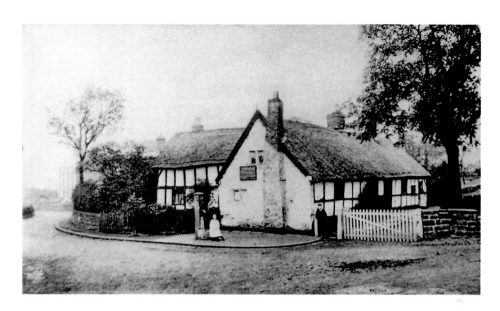

Flower Cottage 1800s and 2010

The cottage on the left is Pump Cottage and that has now been demolished but Flower Cottage remains at the junction of School Lane and Hillside Road. Pump Cottage received its name from the village pump which was situated on the footpath and can be seen in the old photograph.

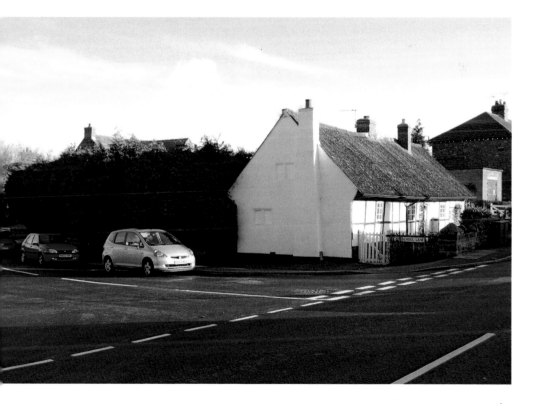

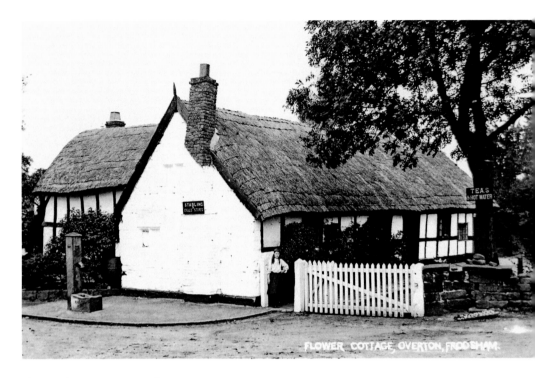

Flower Cottage 1900s and 2010

Another look at this ancient cottage which in the later old photo has had the mullioned windows in the gable end bricked up as they are today. The cottage is Cruck built and was popular with cyclists who were permitted to leave their machines there as they went climbing the nearby hills. Stabling was also provided. The thatch has now gone and been replaced with a more modern, for the period, roof.

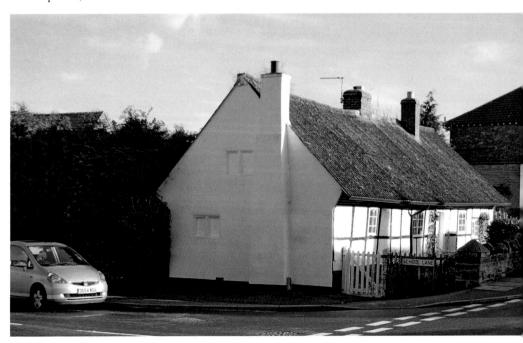

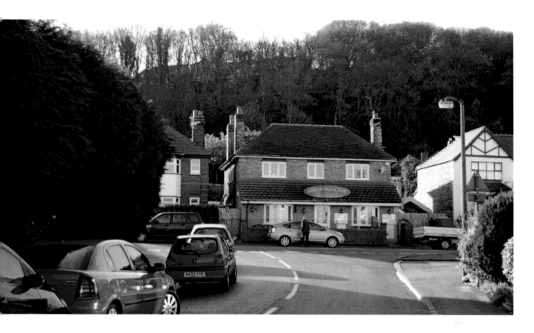

Hawthorn Cottage and Village Pump early 1900s and 2010

This area of Overton was once even quieter and select than it is today. This second view up School Lane to Hawthorn Cottage at the top also gives a clear view of the village pump. Behind the cottage is Overton Hill and the buildings that housed firstly a roller skating rink and then in WW1 a military hospital, after this it spent time as a dance hall. Note the smoke lazily drifting from the chimney, how cosy must it have been inside at this time.

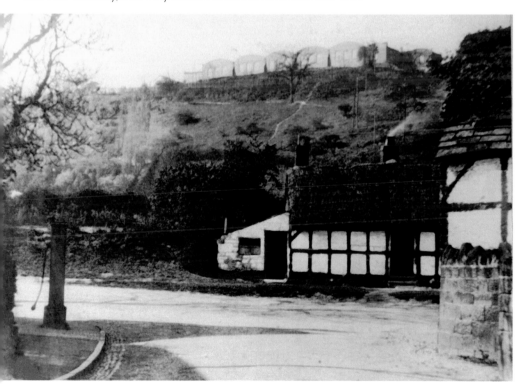

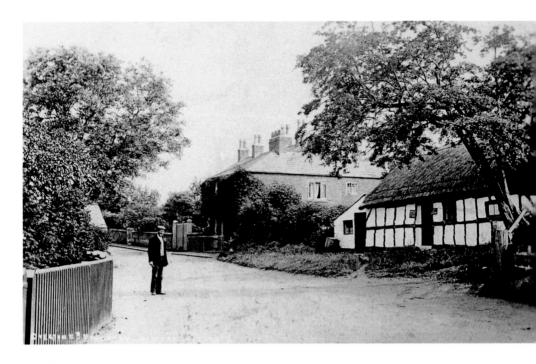

Hawthorn Cottage 1907 and 2010

In this atmospheric shot local monumental mason James Turner is standing outside Hawthorn cottage and observing the camera, his flat cap atop his head and cigarette firmly placed between his lips. What a difference he would see if he could return there today, he certainly wouldn't be able to enjoy his cigarette in the two nearby pubs!

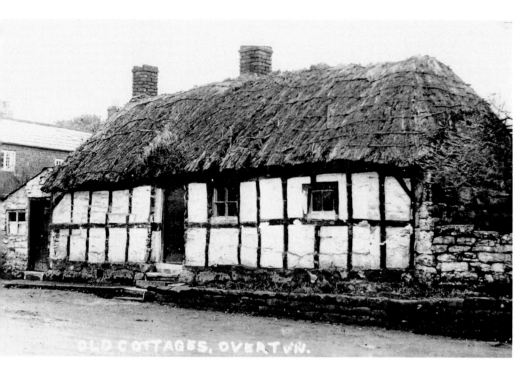

Hawthorn Cottage Overton undated and 2010
A final look at the cottage but by this time it was looking in a sad state. Although the photo is undated I would estimate it as the early part of the last century. A short while later it burnt down. The modern photo was taken during the freezing winter of early 2010.

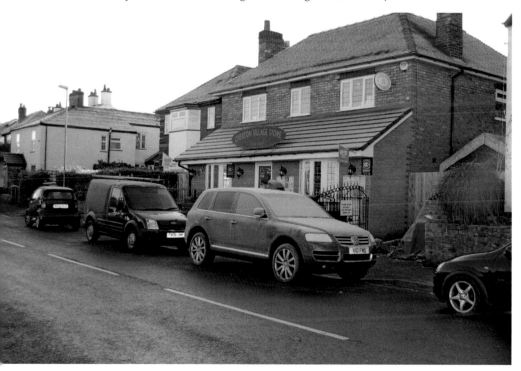

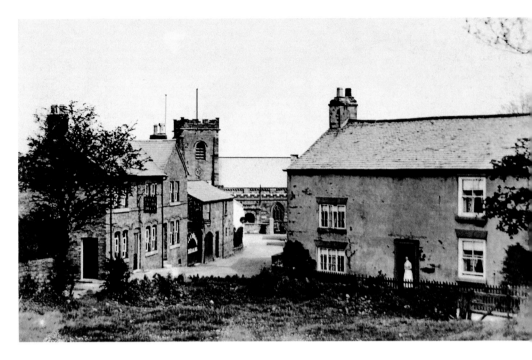

Overton 1900 and 2010

This photograph taken from Hillside Road at its junction with Bellemonte Road looks down towards the church and the two public houses, the first is The Bulls Head, a pub of that name has been on the site since 1794 and in 1828 was known as The Bull Inn. The next building just out of view is the Ring O'Bells that dates from before 1768 when Alice Frodsham was the licensee. The large house on the right was the Manor House.

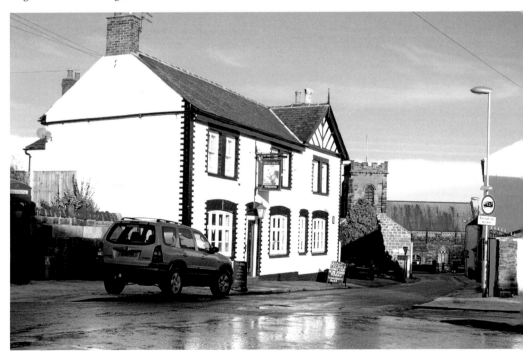

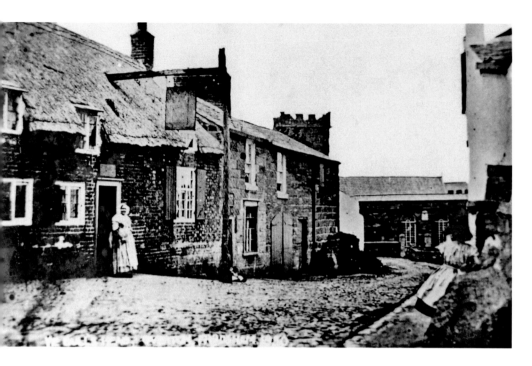

Ye Olde Bulls Head 1850 and 2010

Here we have another ancient photograph of the old Bulls Head pub at Overton. As can be seen it is a different building to the modern one although there has been a Bulls Head there throughout. The licensee at the time of the old photograph was Thomas Wright and the church has yet to be modernised in 1880.

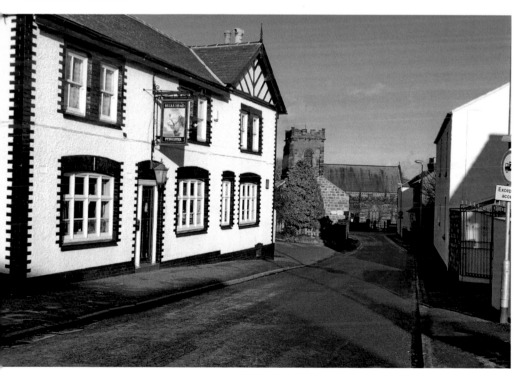

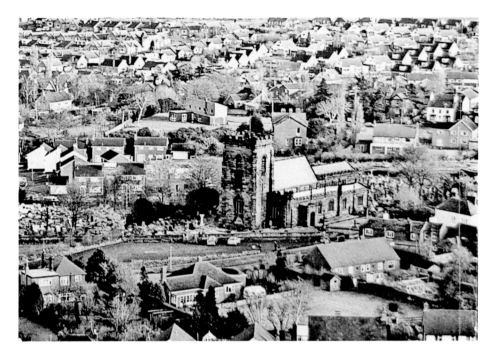

Overton from the War Memorial

High up on Frodsham Hill is the war memorial which was unveiled on the 24th of September 1921 by Colonel Bromley-Davenport the Lord Lieutenant of Cheshire. It commemorates the Frodsham men who gave their lives in both world wars. The view from the memorial is spectacular and it is from there that these two photographs were taken, the first in the 1970s and the second in 2010.

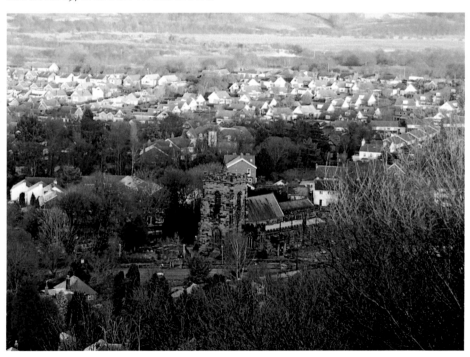

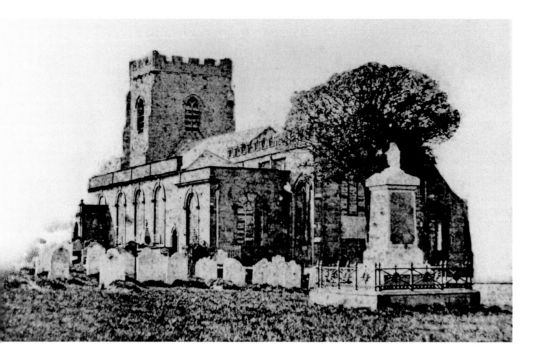

Frodsham Parish Church early 1800s and 2010
This photograph of the parish church of St Laurence at Overton was taken prior to 1880 when it was restored. It is dated after 1862 as that was the approximate date that the large monument in the graveyard was erected to include a family vault containing the remains of Edward Henry Wright aged fifteen of Castle Place who died in December 1861. The house name was later changed to Castle Park.

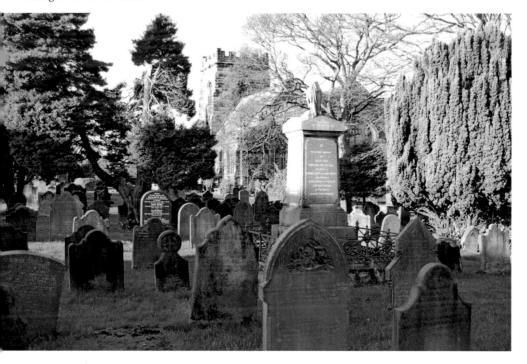

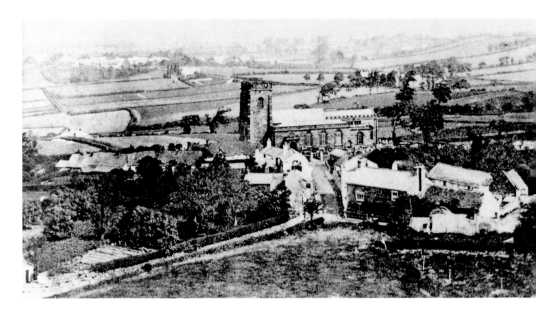

Church from Bellemonte Road 1845 and Anecdote

Another ancient photo of Frodsham taken in 1845, I will take this opportunity to bring together Frodsham and Stratford on Avon through the antics of an earlier vicar!

William Shakespeare purchased New Place, Stratford on Avon in 1597 for £60 as his retirement home. He moved in during 1610 and remained there until his death in 1616. New Place was an impressive building, built by Hugh Clopton and the second biggest in the town at the time. On the death of his wife Anne in 1623 the house was returned to Sir John Clopton who renovated it and opened it to the public.

The eccentric Reverend Francis Gastrell was vicar of Frodsham between 1740 and 1772 and he purchased New Place. In 1759, upset by the constant stream of people looking over the wall, he took out his ire by chopping down the mulberry tree that Shakespeare had planted causing the infuriated Stratford inhabitants to retaliate by smashing his windows. In a final act of madness, this time annoyed at land tax demands, Gastrell razed New Place to the ground. Gastrell was driven out of Stratford by the locals and a by-law was passed banning anyone of the same name from living in Stratford forever.

Now, thanks to this Frodsham vicar, visitors to Shakespeare's home can only view the beautiful gardens, the foundations and a mulberry tree supposedly grown from a cutting. At least whilst incumbent at St Laurence's in around 1760 he donated most of the church plate!

The smaller photo shows the dedication to him and his wife on the Frodsham church wall.

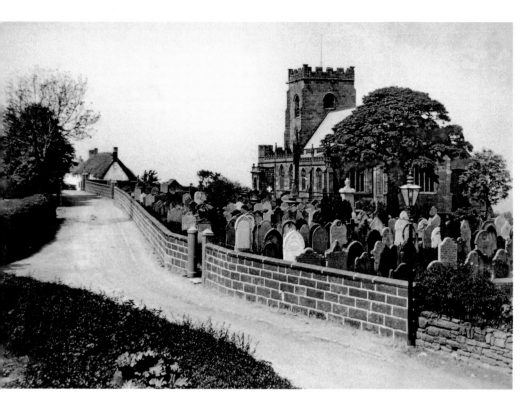

Frodsham Parish Church early 1900s and 2010

A church on this site can be traced back to the Domesday Book when a Saxon chapel was recorded as being here. The nave can be dated back to the twelfth century and as can be seen in other photos in the book of this area, it was once the centre of a thriving community. In the old photo we can see the cottages at the end of the road that is now the church car park.

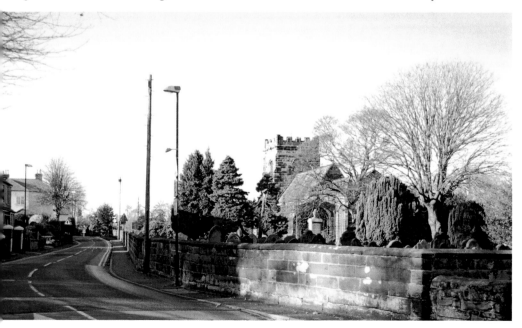

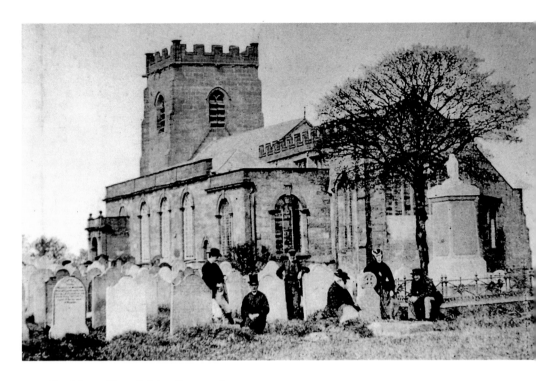

Frodsham Church late 1800s and 2010

This is another ancient pre-1880 photograph of the church and included in the people in the photo is the vicar Reverend William Cotton, 1857 to 1876, fourth from the left. He gained fame by introducing bees to New Zealand, well, he did go to New Zealand and he wrote a respected book on bee keeping but whether he was actually the first to introduce them to the antipodes is another matter. The sexton Mr F. Unsworth carved a bee in stone and the bee now features on Frodsham's historical signs as you can see in the insert.

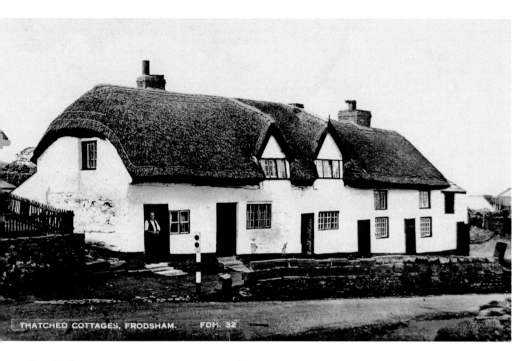

THATCHED COTTAGES, FRODSHAM. FDM. 32

Thatched Cottages Howey Lane 1932 and 2010
These pretty cottages once stood at the top of the gradient in Howey Lane opposite what is now the church car park. The area is known as Pinmill Brow. As the photograph was only taken in 1932 and the cottages are obviously in good external condition, just why did anyone see the need to demolish them?

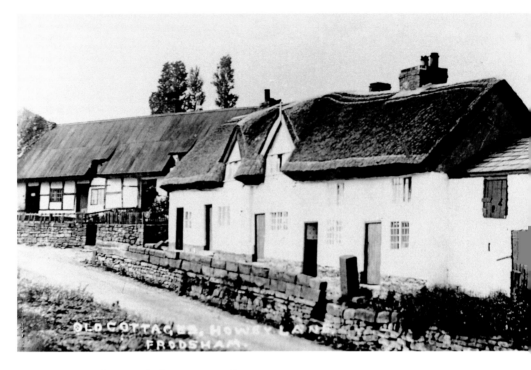

Howey Lane early Twentieth Century and 2010

A look now at the same cottages from an earlier date and from the opposite direction, the pole with the red reflectors seen in the previous photograph has not been erected but the cottages are in excellent condition. Note the barn at the end of the row.

Langdale Way 1960s and 2010

Back now to Langdale Way off Fluin Lane for a look at the estate in its infancy, we see that the Langdale Store and further shops have been built, and the traffic has increased somewhat. The houses on the left were sold for £1,800 each and were fitted with galvanised baths when new.

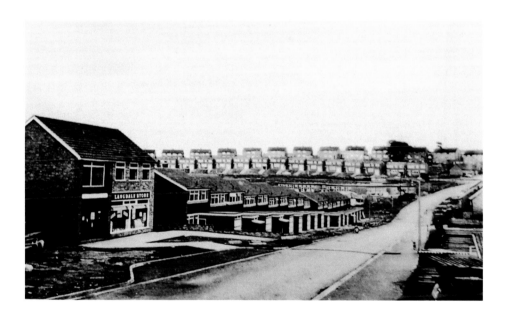

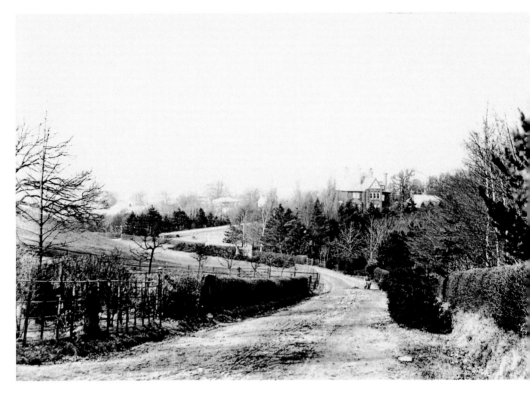

Carriage Drive 1900 and 2010
This quite road leads up to Frodsham Hill and the later mentioned area known as Jacobs Ladder. The large house in the old photograph and hidden by trees in the new one is Hemp Gill and in 1902 Alfred Thomas JP was in residence.

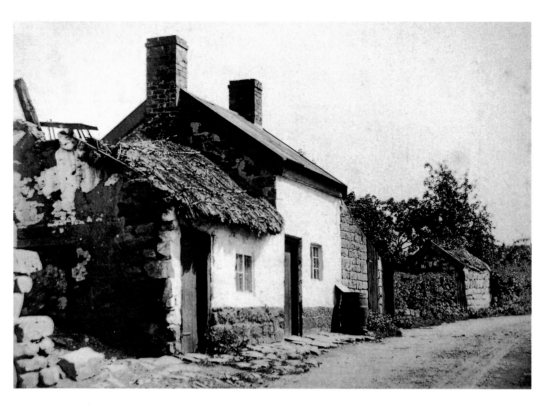

Iron Dish Cottage Godscroft Lane 1900 and 2010
This old cottage has now been replaced by Iron Dish Farm as the modern photograph shows; where the unusual name comes from I don't know. I would surmise that in this area many Iron Age artefacts were found and this could be the answer.

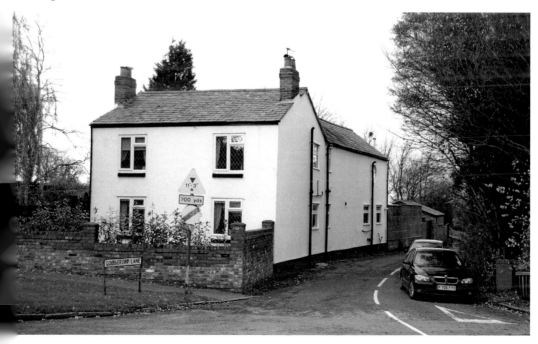

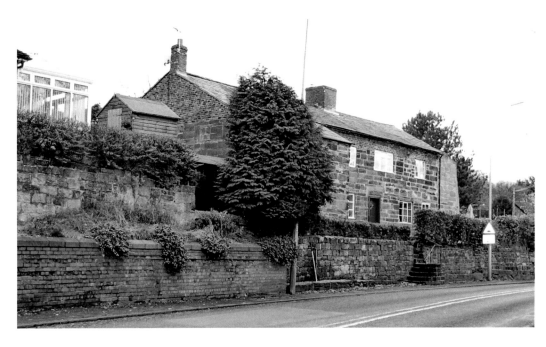

Rock Cottage Netherton undated and 2010

This house standing on the main road from Frodsham to Helsby is in the hamlet of Netherton.
The well-worn steps leading down to the road have been replaced with a new set and the ivy has
been removed. Other than that, little has changed over the years.

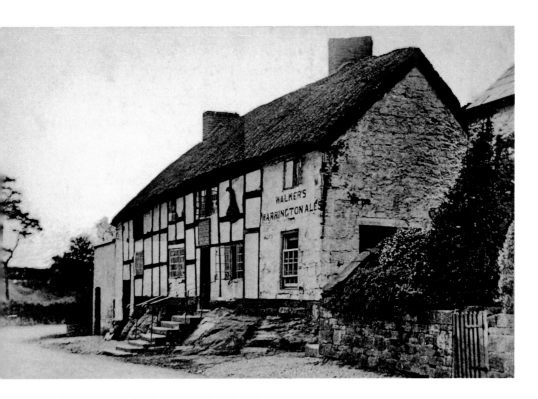

The Whalebone Inn Netherton undated and 2010

The Whalebone Inn had been in existence since 1794 and the first landlord was John Bate, 1794 to 1797. During the last century it also went under the names Fishbone, Blade Bone and simply The Fish. Robert Mather and Co is shown as the owners in 1872 and Walkers in 1905. A large bone hangs on the front above the window, it is said that it came from a whale washed up on Frodsham marshes. In 1980 (just after the inset photo was taken) it was demolished and its licence transferred to the Netherton Hall pub that can be seen in the modern photo.

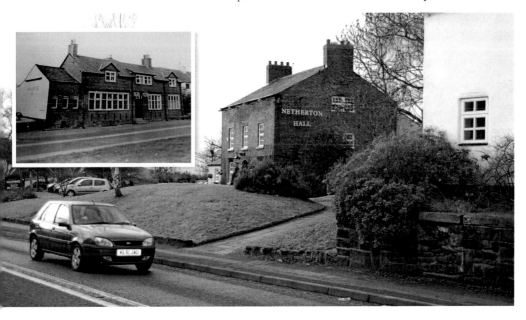

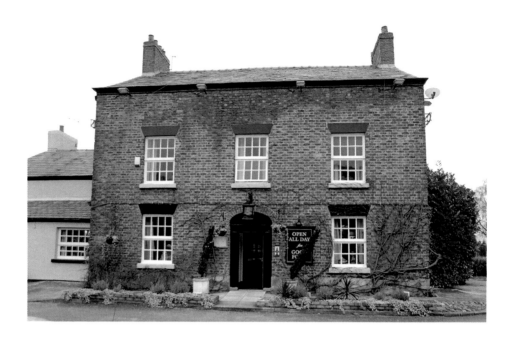

Netherton Hall 1900 and 2010

This building is now an excellent pub-restaurant standing on the site of the former Netherton Hall that was demolished many years ago to make way for this building and the one shown in the old photograph. This was taken at the turn of the last century when the building was a farmhouse, the farmer being Mr Arthur Clark. The people in the photo are his wife, his son Sydney who later took over the farm but died at the age of thirty-five and one of the servants Miss Sally Anderson.

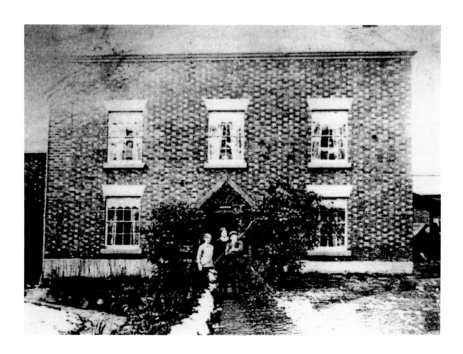

Jacob's Ladder 1900s and 2010
This well-known feature of the Dunsdale
area in the Frodsham Hills was always
popular with walkers. Even at the turn
of the last century when ladies did their
walking in ankle length and modest skirts.
On this occasion however the lady precedes
her more comfortably dressed male
companion!

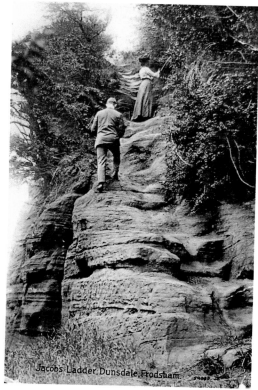

Jacobs Ladder, Dunsdale, Frodsham.

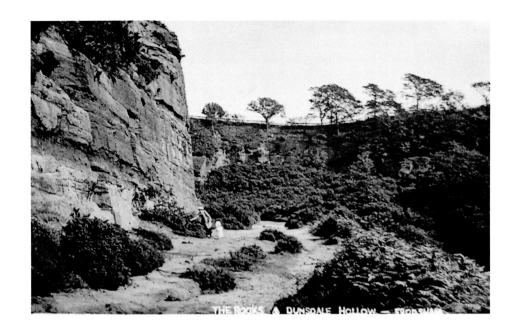

The Rocks and Dunsdale Hollow early 1900s and 2010
Just beside Jacob's Ladder is Dunsdale Hollow which takes the walker around the edge of the hill. The lady in this old shot is again unsuitably dressed and the little girl with her would certainly be more comfortable were she not in her confirmation dress! The modern photo shows an increase in tree growth over the years.

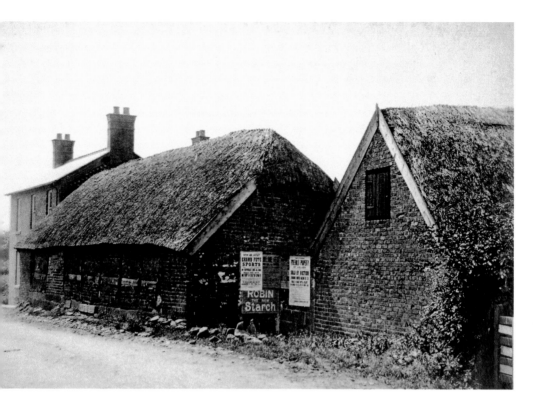

Woodseaves Cottages Tarvin Road undated and 2010
Tarvin Road leads away from the Helsby Frodsham Road and cuts through Delamere Forest to Tarvin. These ancient cottages were situated in a quiet part of the lane at the Helsby end. The date is not known but the advertisements are for a grand fête and for the auction of a local property. Also included is an ubiquitous advert for Robin Starch. The modern photo shows that yet another antiquity has been swept away; at least the brick built house is still standing.

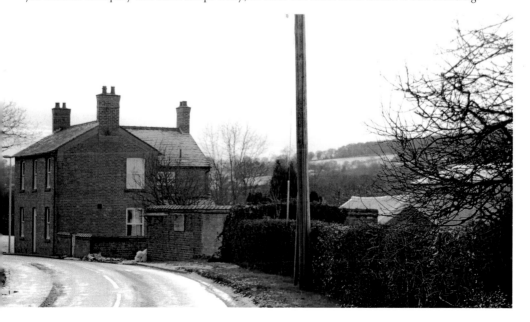

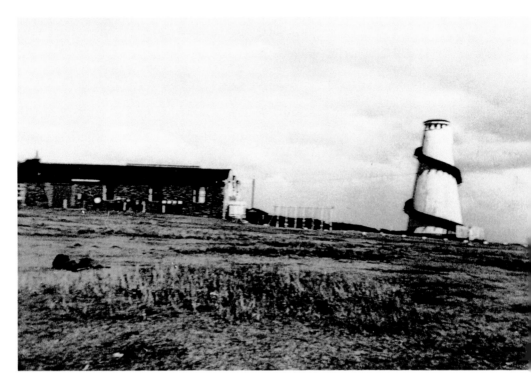

Overton Hills undated and 2010

No book on Frodsham would be complete without at least one shot of the once extremely popular Overton Hills Pleasure Grounds. These have existed since Mr Robert Brisco built a tearoom here in 1865. Thereafter it went from strength to strength mainly under the direction of his daughter, Mrs Parker Hoose, who was the proprietress at the turn of the last century. In 1908 she ordered the building of the Helter Skelter and the pleasure grounds continued to grow attracting visitors from far and wide. The area now houses the Forest Hills Hotel and the Mersey View nightclub.

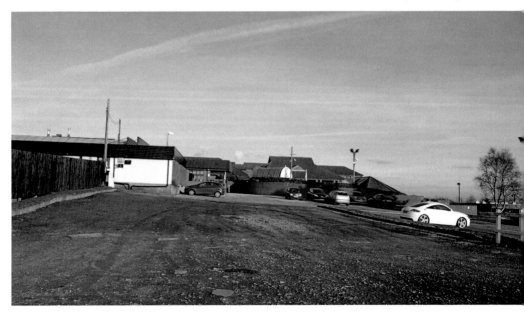

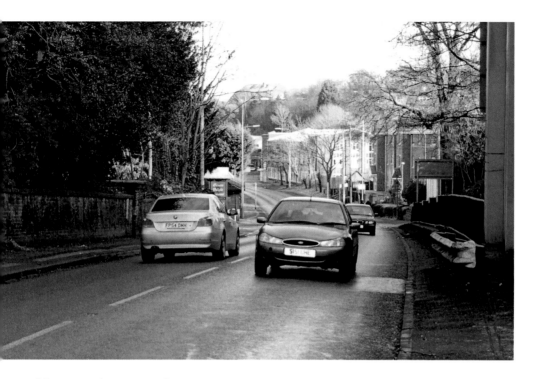

Bridge Lane View 2010 and 1900
We are now in Bridge Lane, a continuation of High Street and we stop to look back down the hill, at this point a footbridge spans the road in the old photograph. The Cruck Barn that is mentioned on page 89 can be seen on the right.

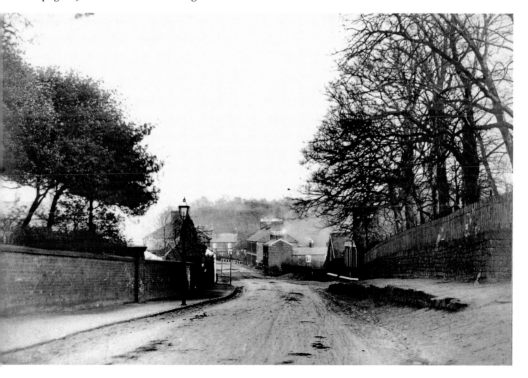

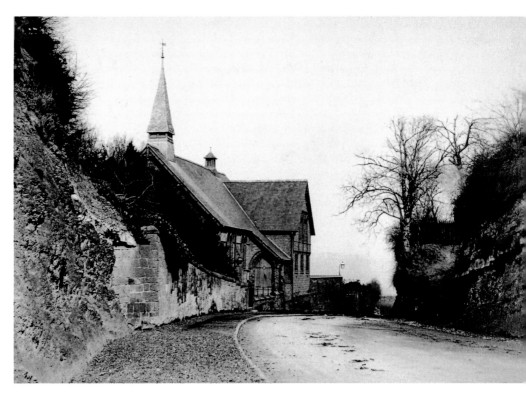

Union Baptist Church Bridge Lane early 1900s and 2010
Built in 1886, this Union Chapel was designed by the famous Sandiway architect John Douglas. It then went on to serve the people of Frodsham for 120 years until 2006 when it closed to be converted into flats.

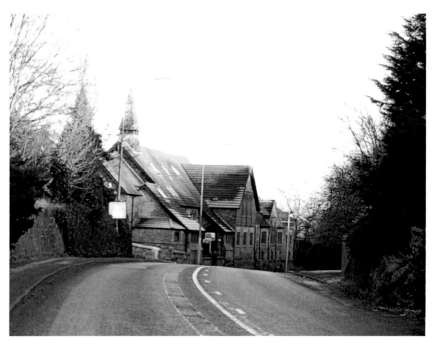

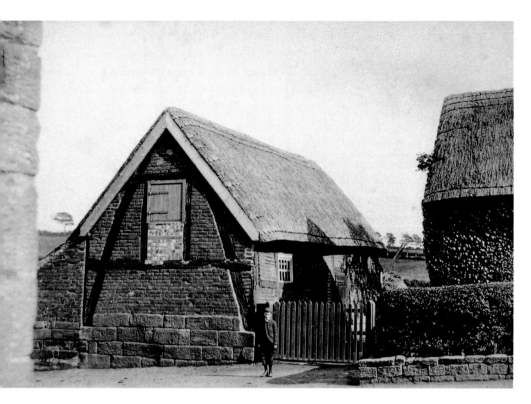

Sharps Farm Bridge Lane early 1900s and 2010
Continuing towards Runcorn along Bridge Lane, which was once the centre of a farming community, this ancient barn was once situated opposite what is now the Chinese restaurant.

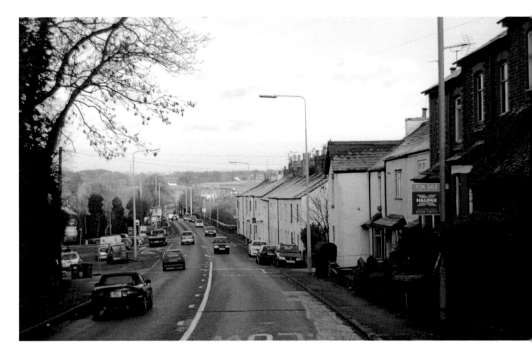

Frodsham Bridge 2010 and 1900

Towards the bottom of Bridge Lane now we approach the bridge over the River Weaver. Here is an excellent example of then and now with the new photo showing a road congested with traffic and the old one a pony and trap travelling leisurely up the hill towards Frodsham.

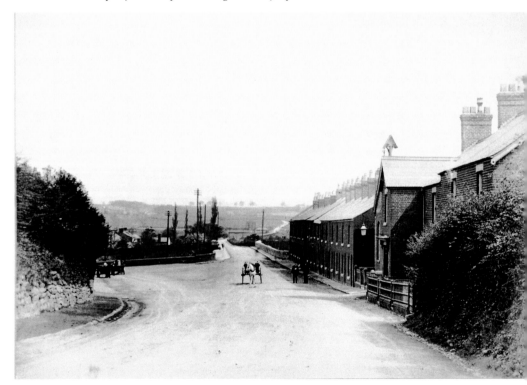

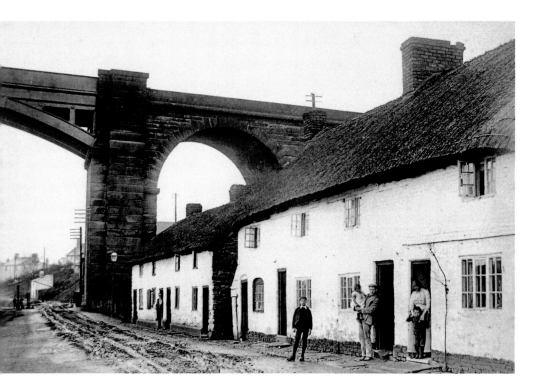

The Quay, early 1900s and 2010

As we near the bridge in Bridge Lane we turn left and down a narrow road reach Frodsham Quay. This once bustling area of mills and shipping has now given way to a pleasant walk with new and modernised houses on the banks of the Weaver. In the old photograph we see the mill workers thatched cottages and in the new one they have gone although some may remain but having been renovated. The railway arches and bridge tower above the track.

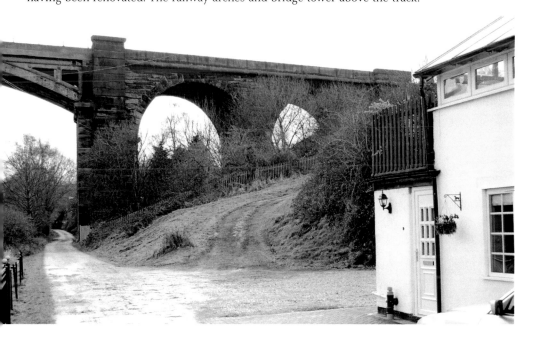

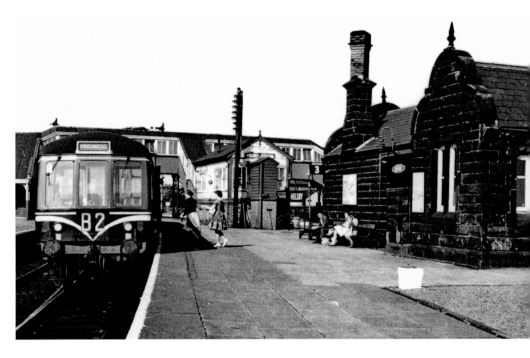

Helsby Railway Station early 1960s and 2010
We now travel to Helsby and stop at the railway station, in the old shot is a 'cat's whiskers' diesel railcar on the way to Birkenhead. This pretty sandstone station is a junction with lines coming in from the Wirral, Chester and at one time Mouldsworth.

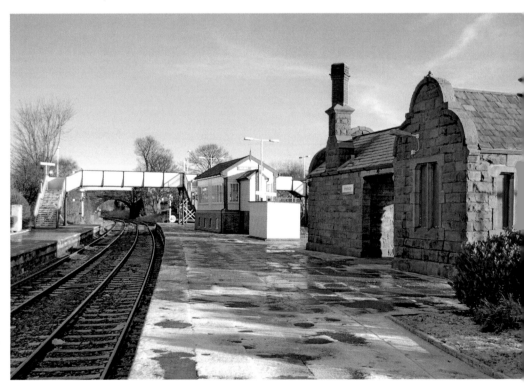

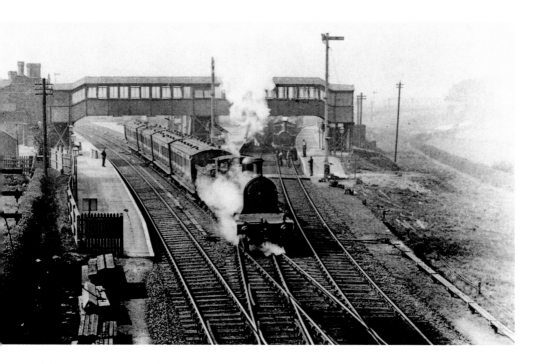

Helsby Station 1920s and 2010

This atmospheric photograph of Helsby station shows the trains from the Chester direction leaving the station and travelling towards Frodsham. A train from the Ellesmere Port direction is waiting at the platforms whilst milk churns await the train on the Chester bound side. Over the intervening years the footbridge has been replaced and lost its roof whilst little else has changed.

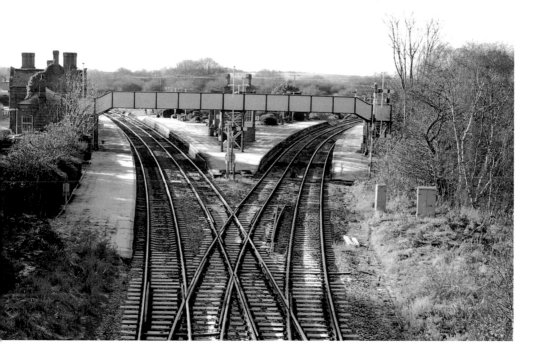

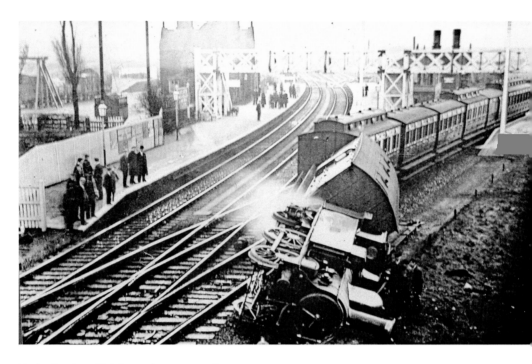

Train Crash at Helsby early 1900s and 2010
The engine in the old photograph has become derailed whilst leaving the platform from the Wirral. Note the wagons in the sidings on the far left and in the modern photograph the sidings have gone and this area now has houses. The footbridge is yet to receive its roof.

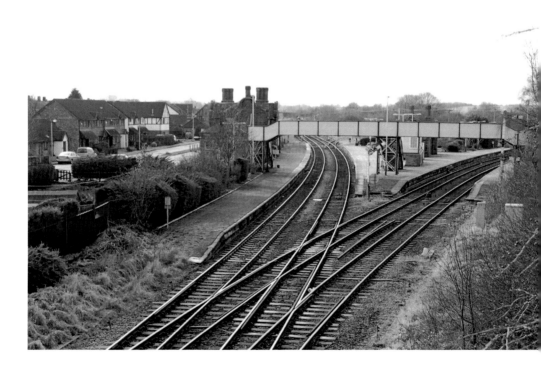

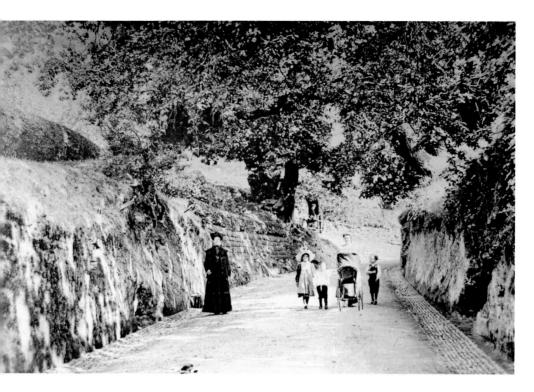

Rake Lane Helsby early 1900s and 2010
This narrow lane leading up to Old Chester road cuts through the rock and during the late 1800s and early 1900s a woman and children with perambulator come down the hill towards the station. Next to them is an elderly woman in her widow's weeds as worn by Queen Victoria who would still have been on the throne at this time.

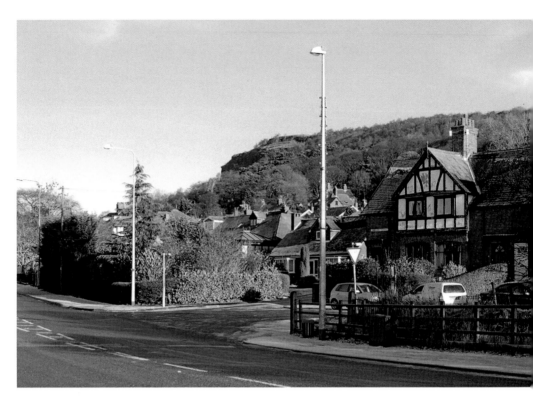

Helsby Hill undated and 2010

What better way to end this look at Frodsham and Helsby than with a photo of the famous man's face as seen on the rock face of Helsby Hill. In the old photo the face is more pronounced without the addition of houses. A view enjoyed by people using the nearby M56 motorway.

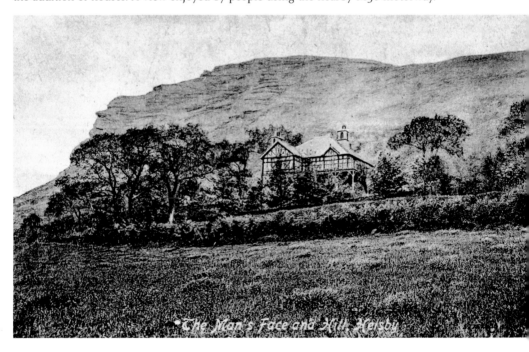

The Man's Face and Hill Helsby